Coloring can be a soothing meditation, an activity to lose yourself in. It can also be mind-expanding entertainment, so turn this page and begin!

coloring magic
EVAN4SH.coM

2ND Edition

Kykeon

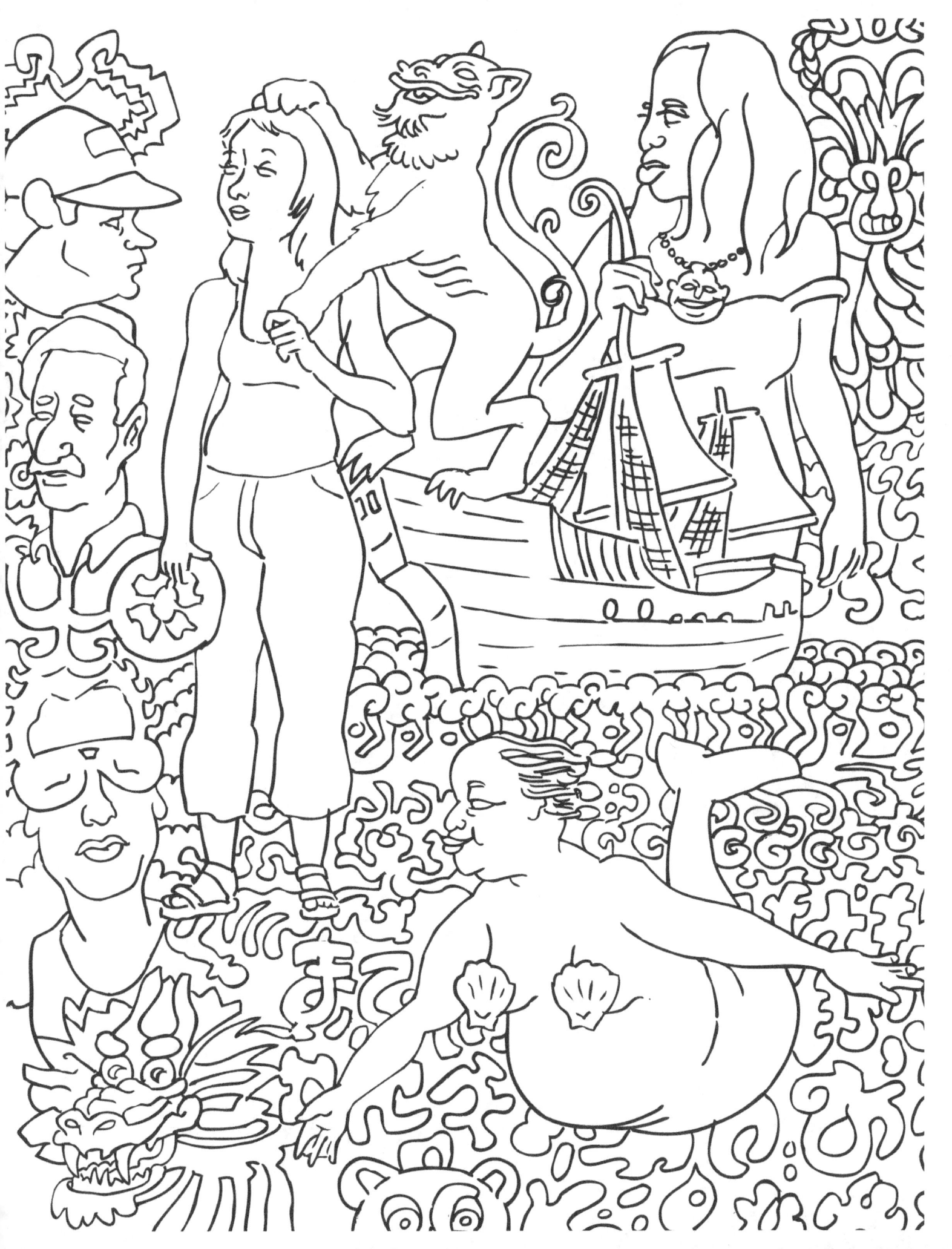

Agathos Diamon

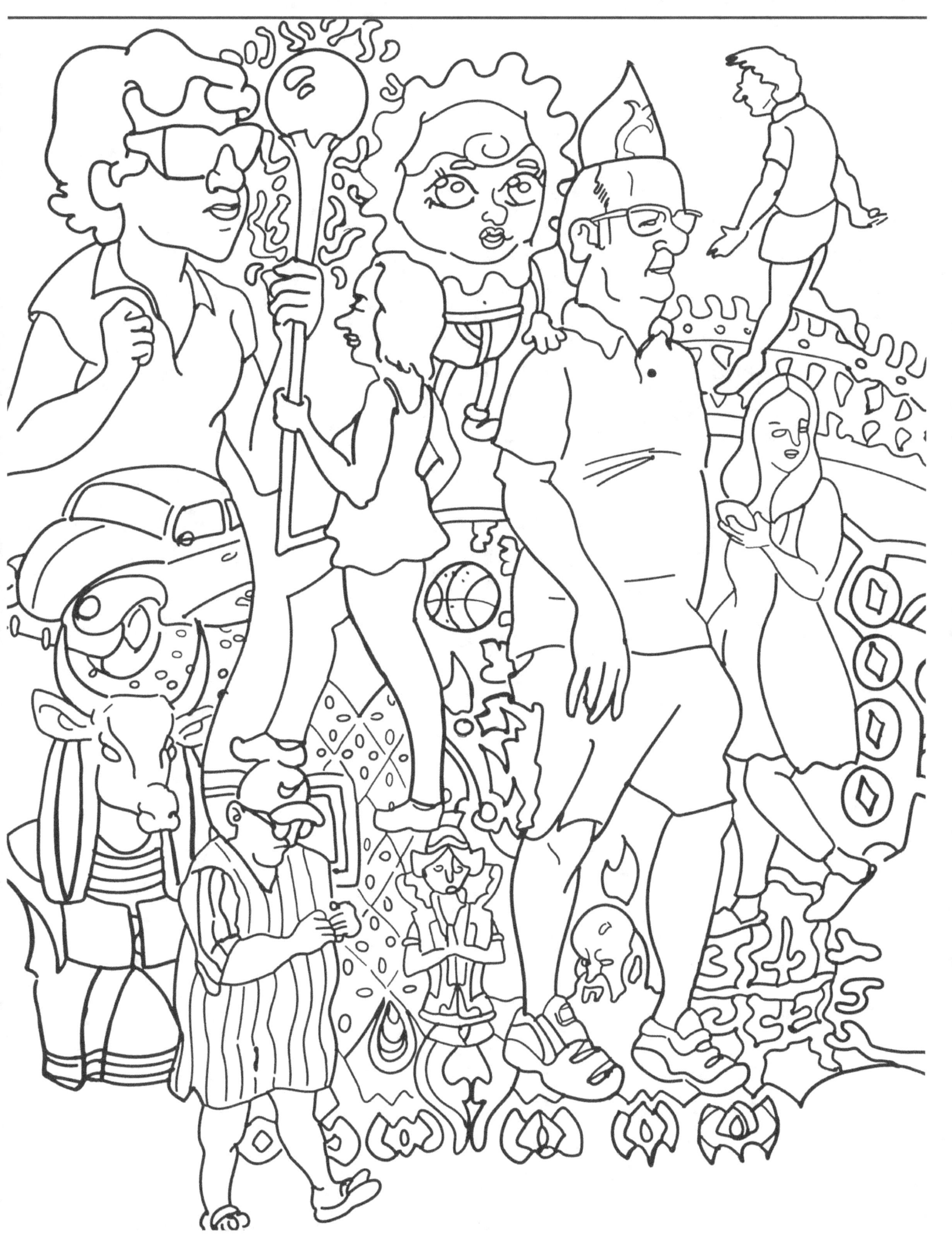

Heterozygosity

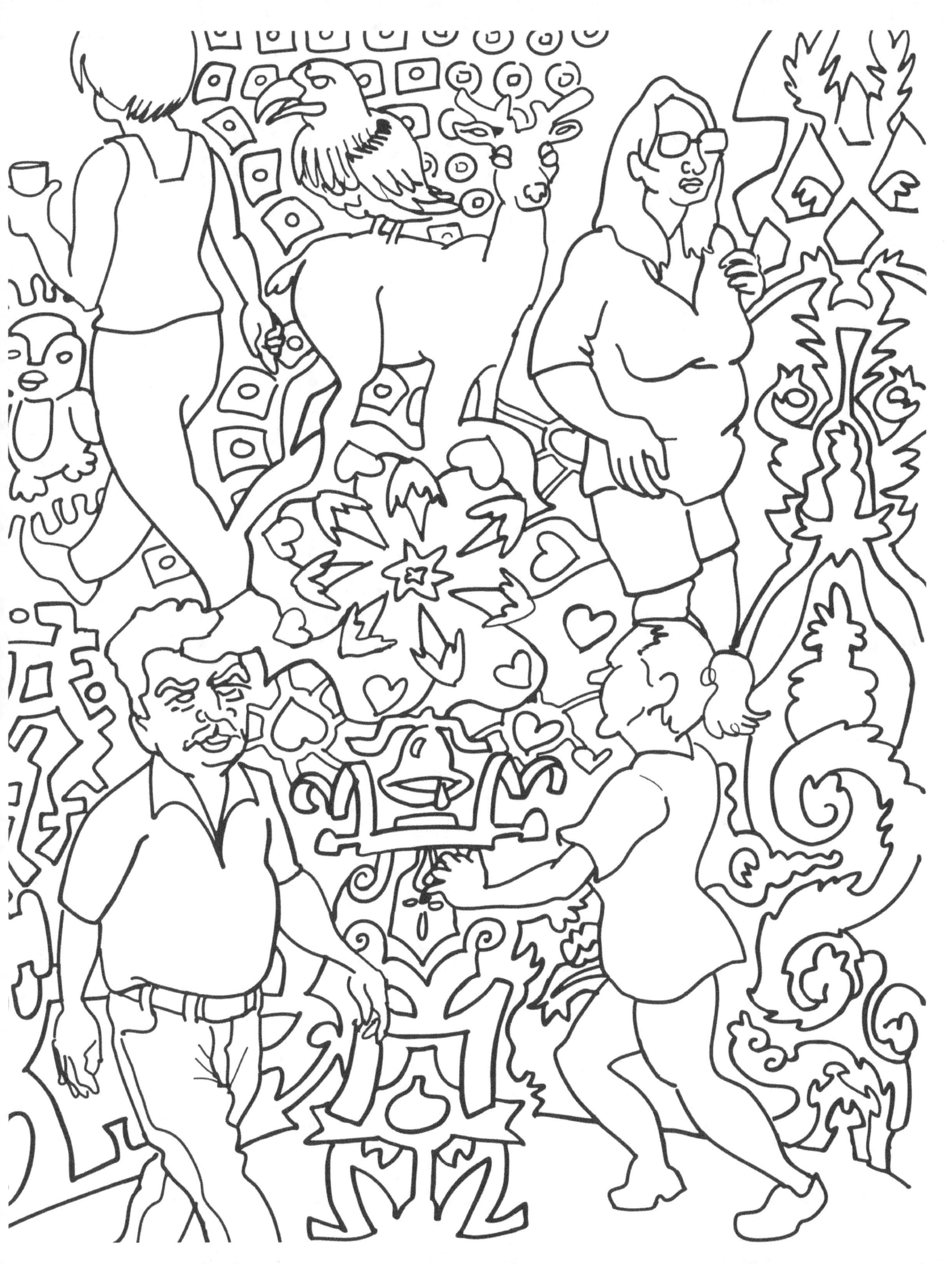

Satoshi Nakamoto

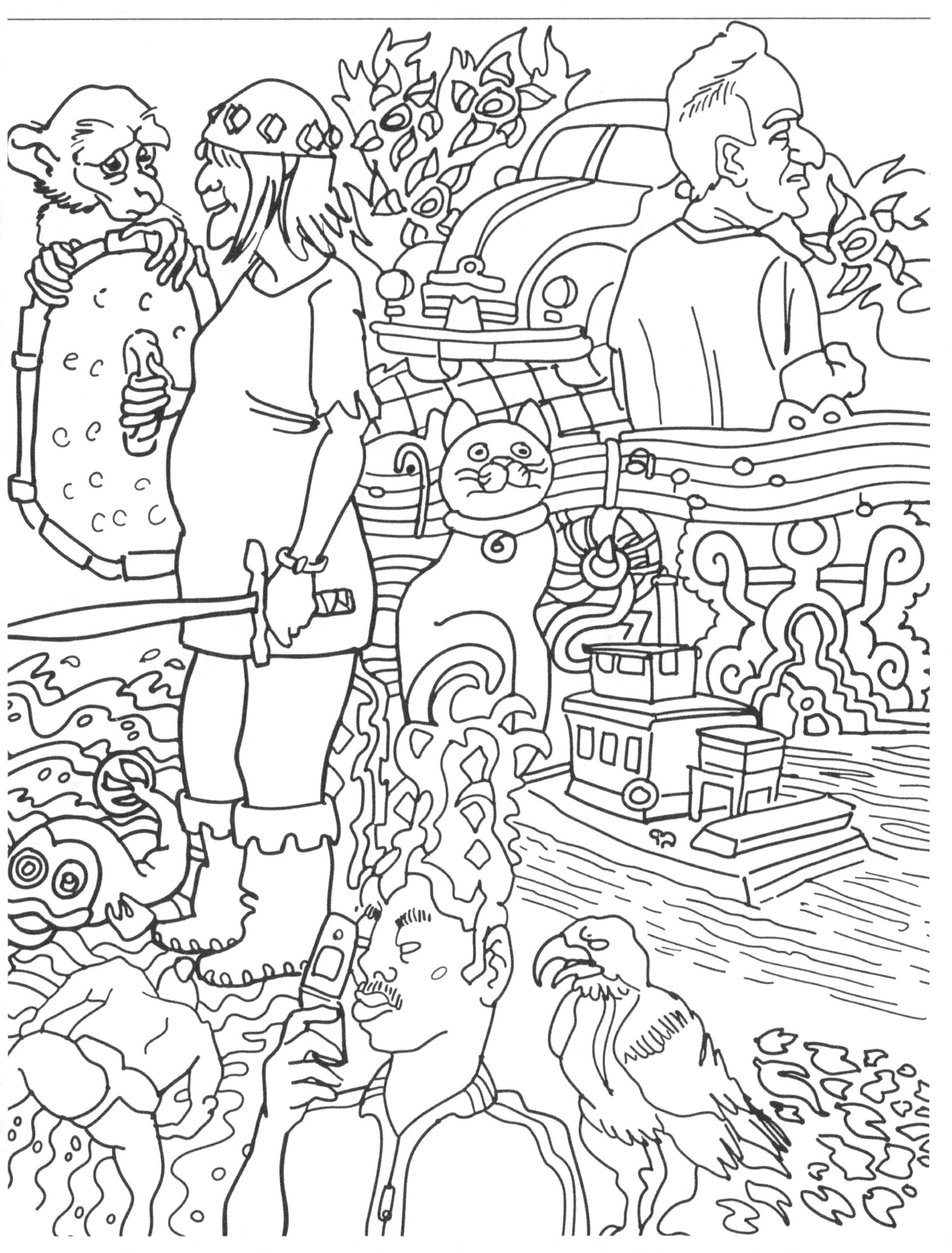

Therianthropes

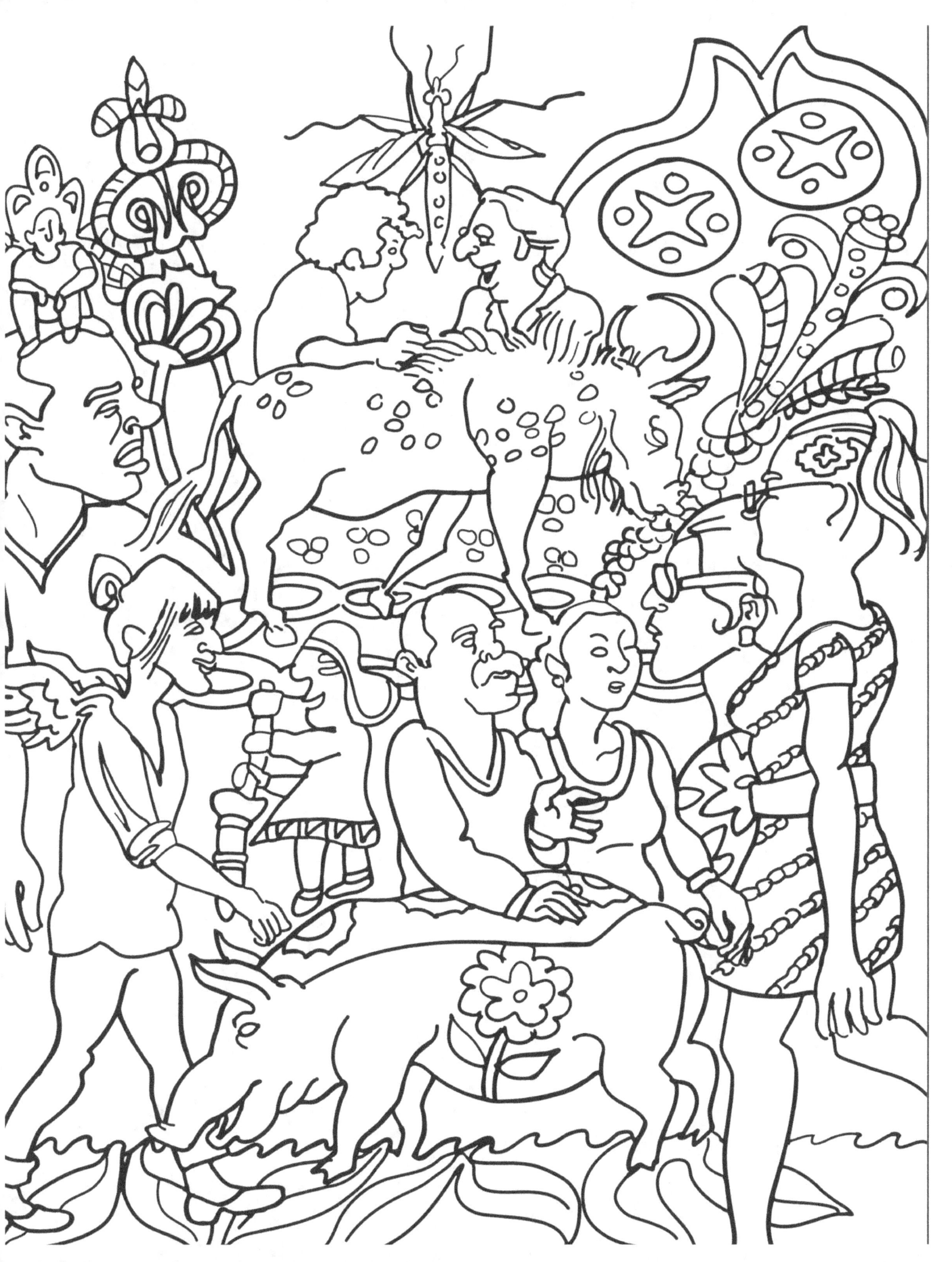

Benjo

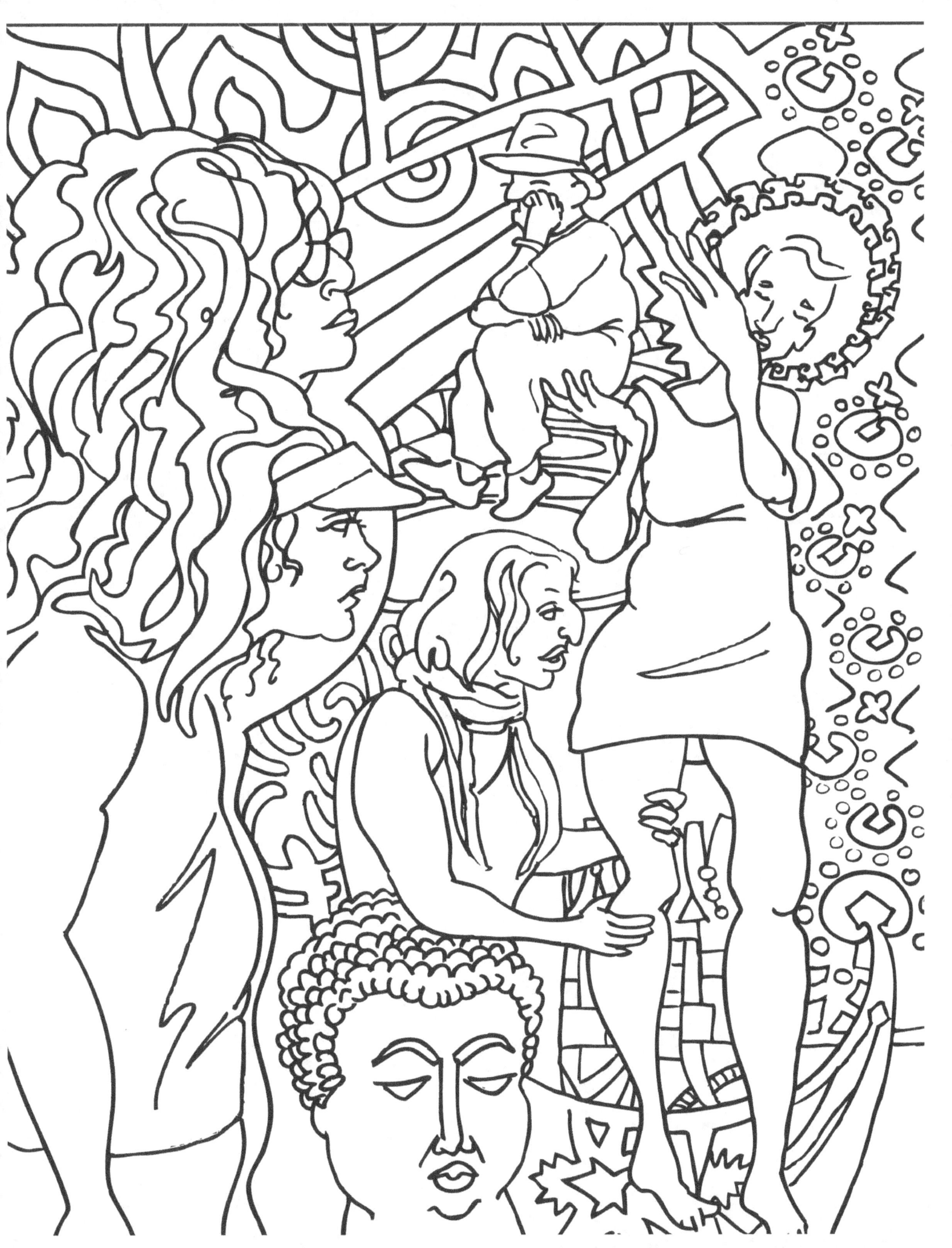

Telepathine

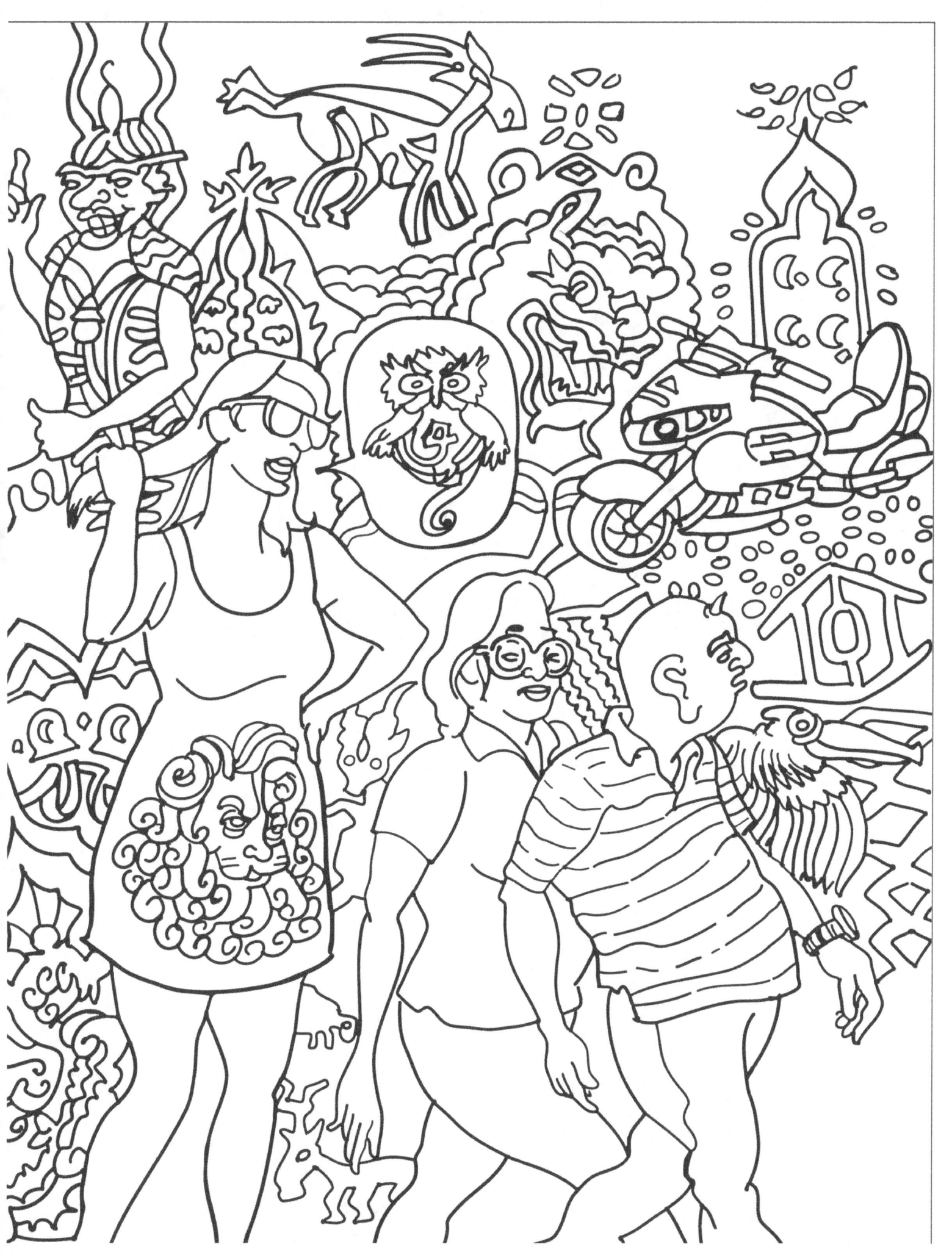

Yahoel

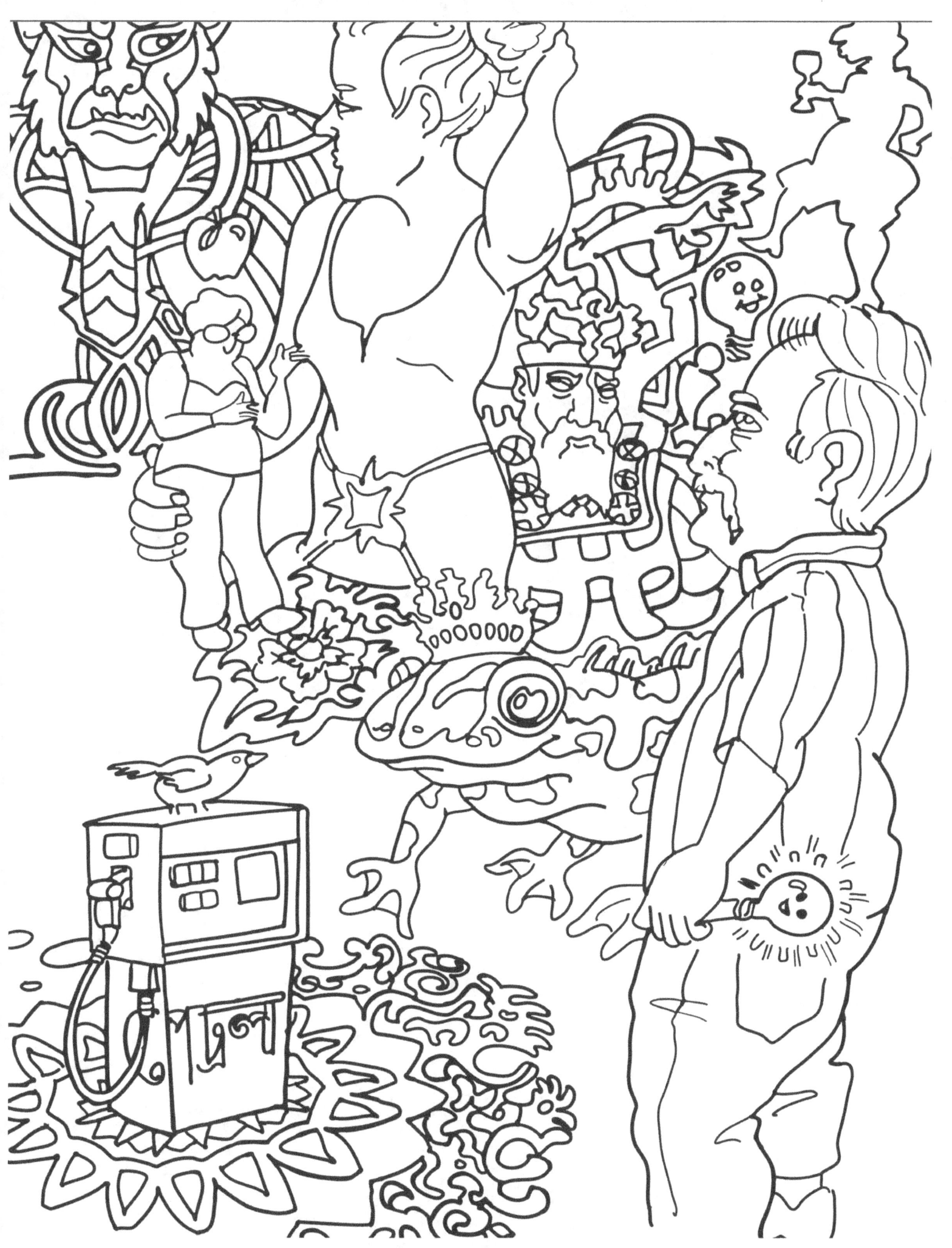

Ihamba Ritual

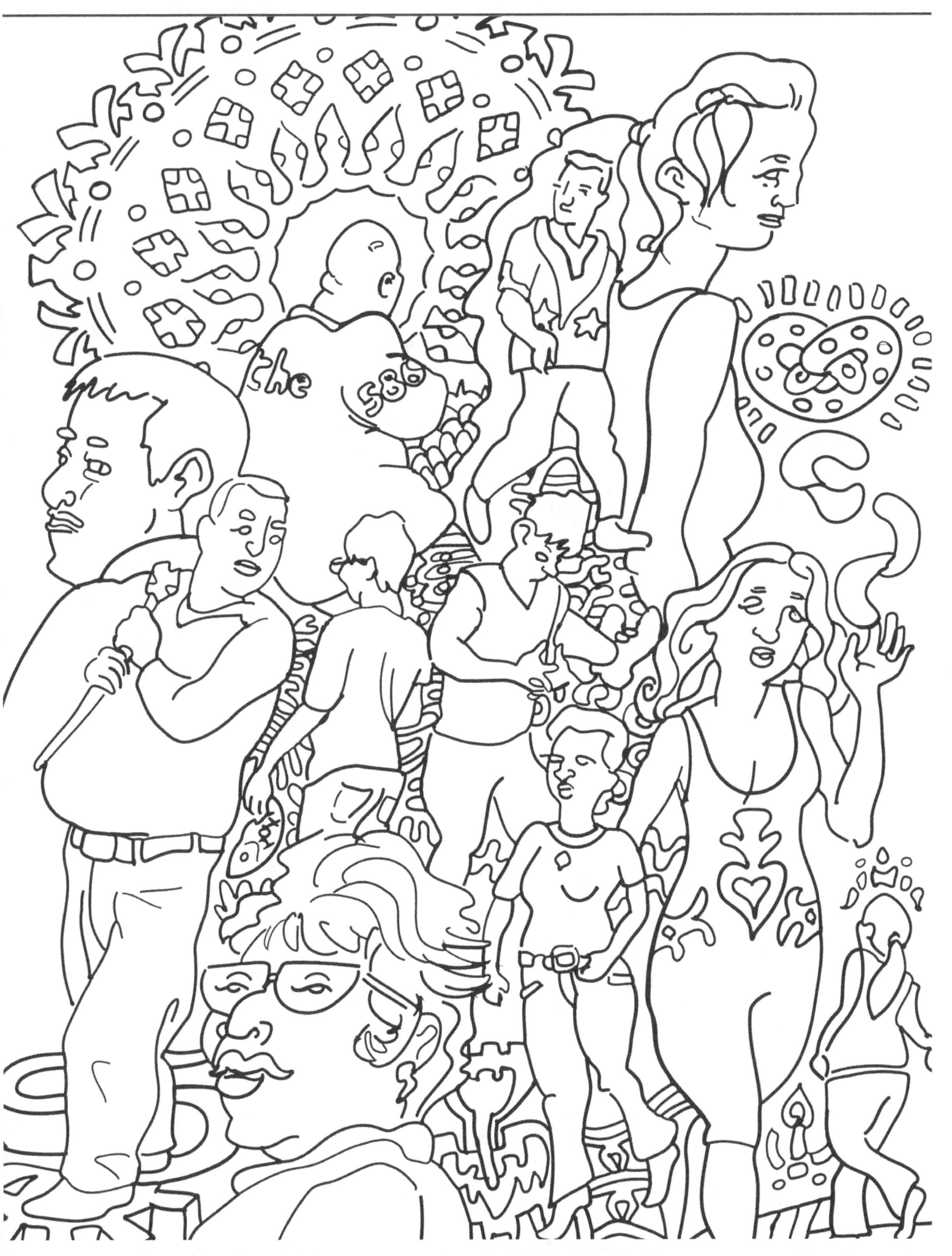

Morphogenetic

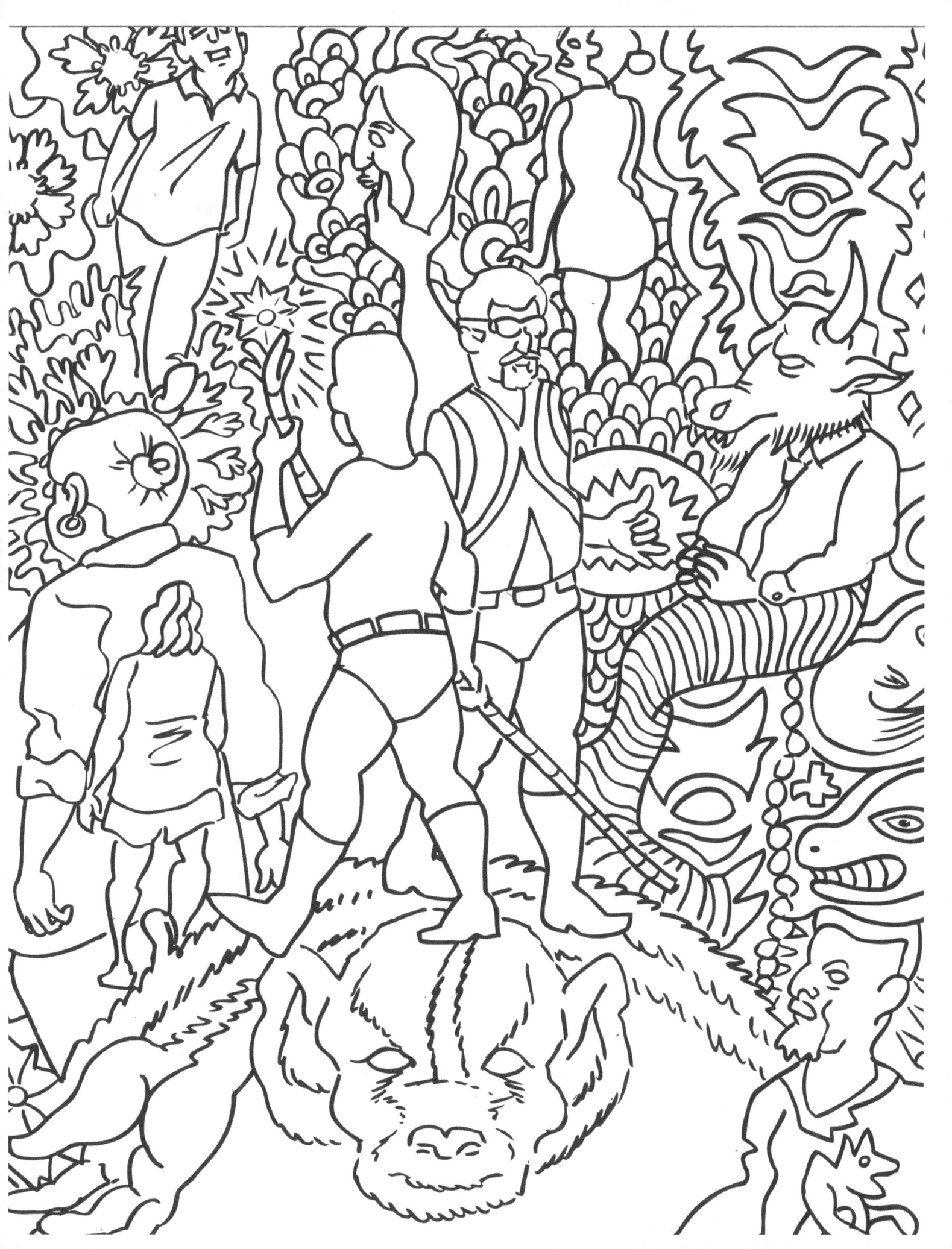

Lac de Gafsa

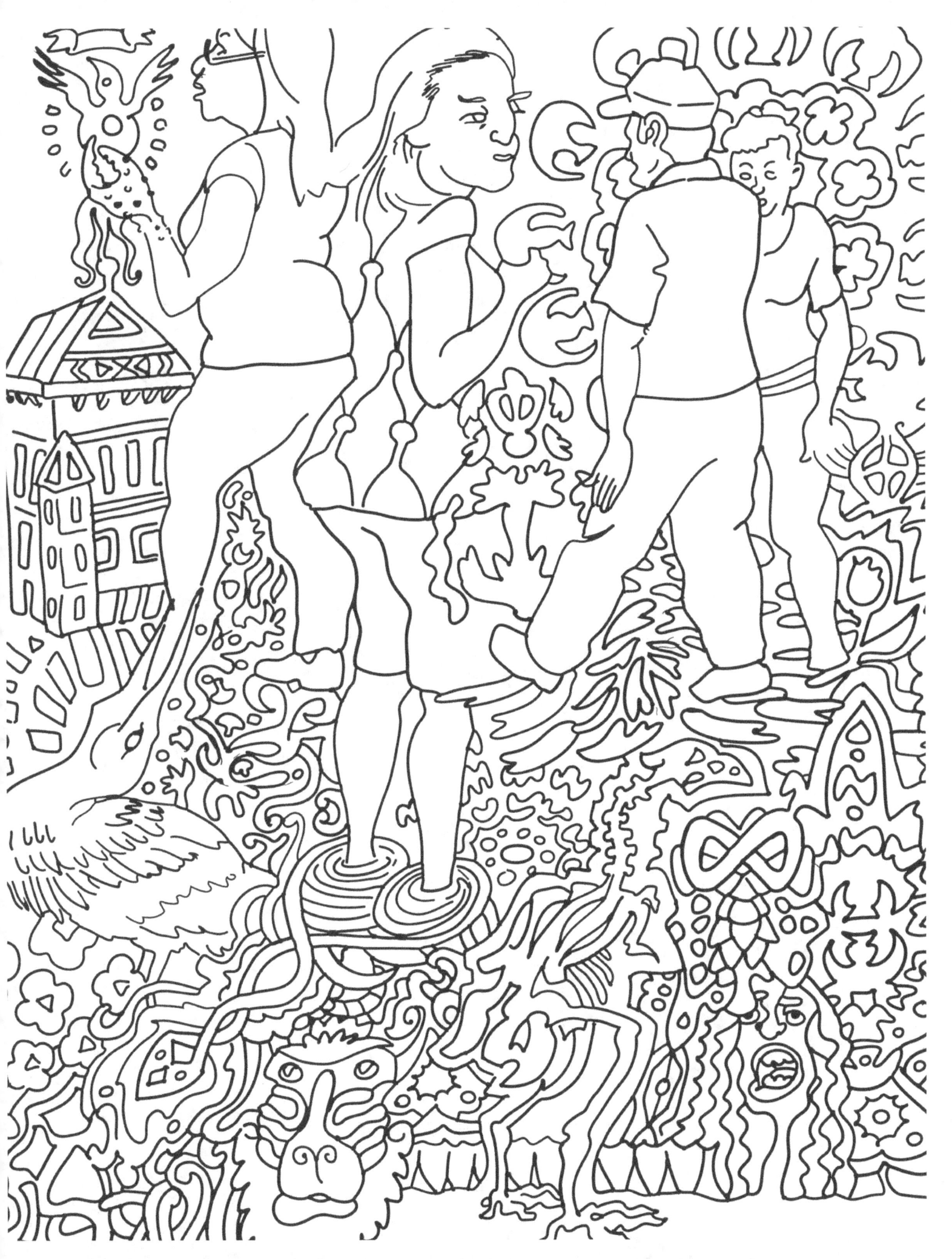

Window Area

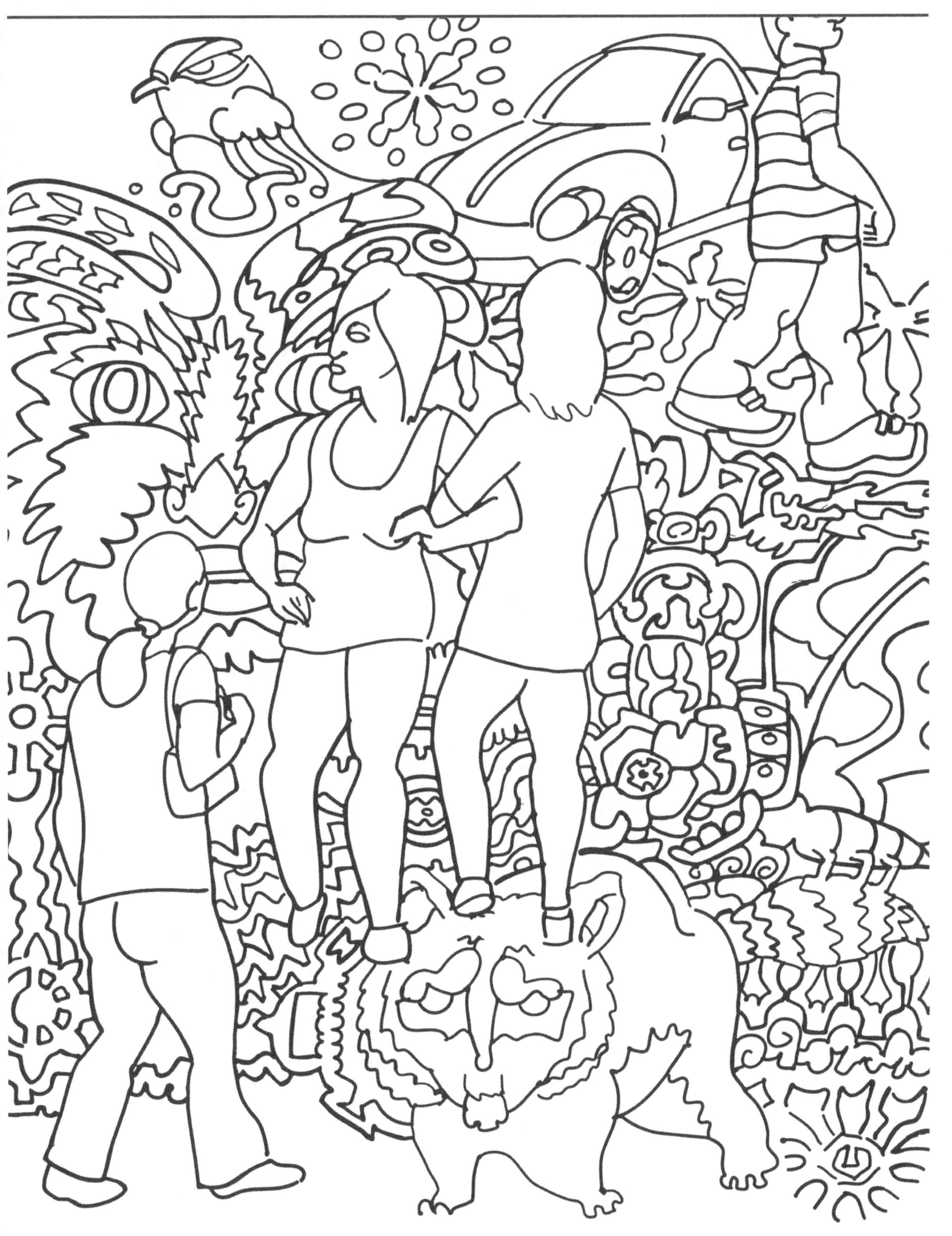

tDCS

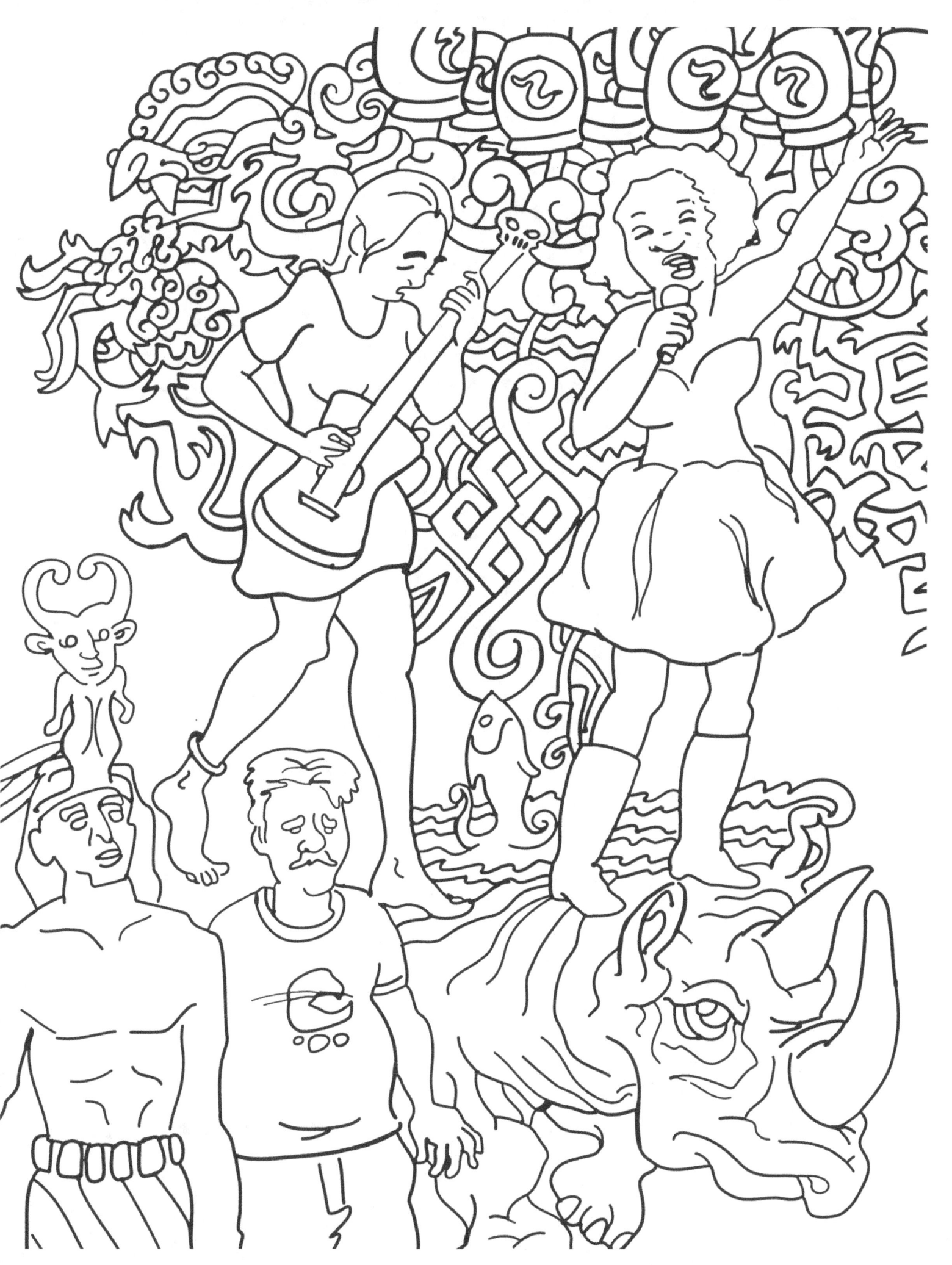

Yellow Hypergiant

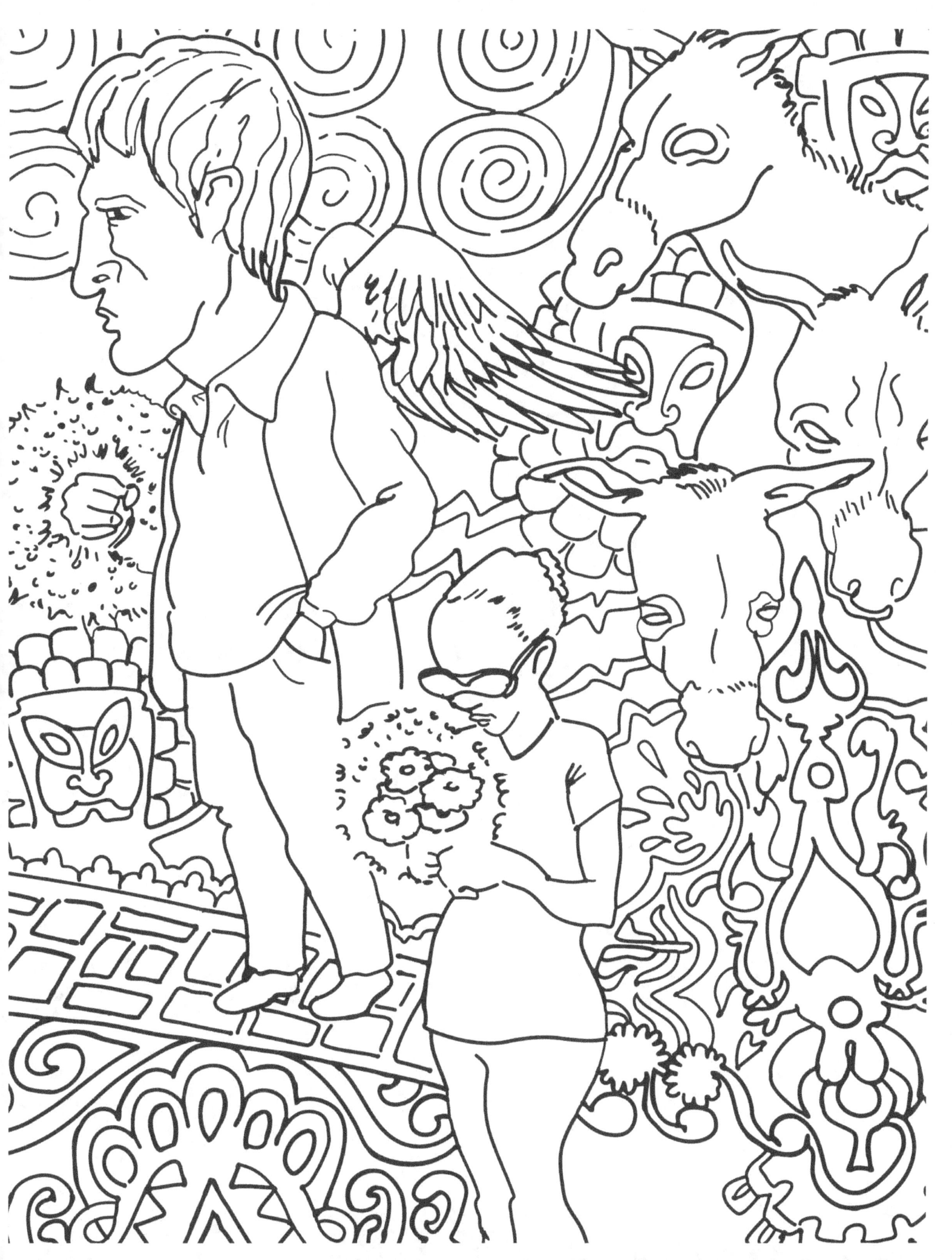

Schlaraffia

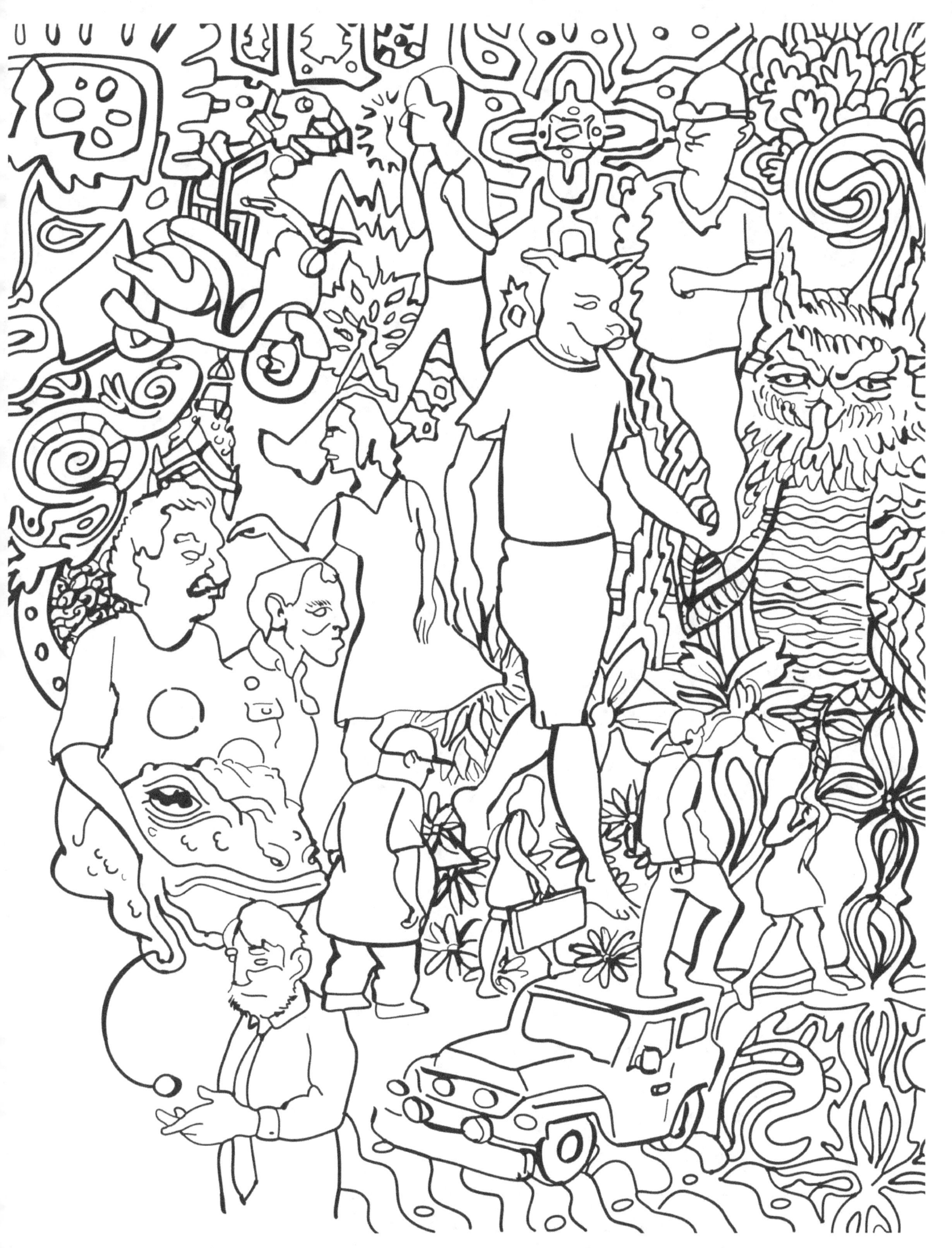

Contraindications

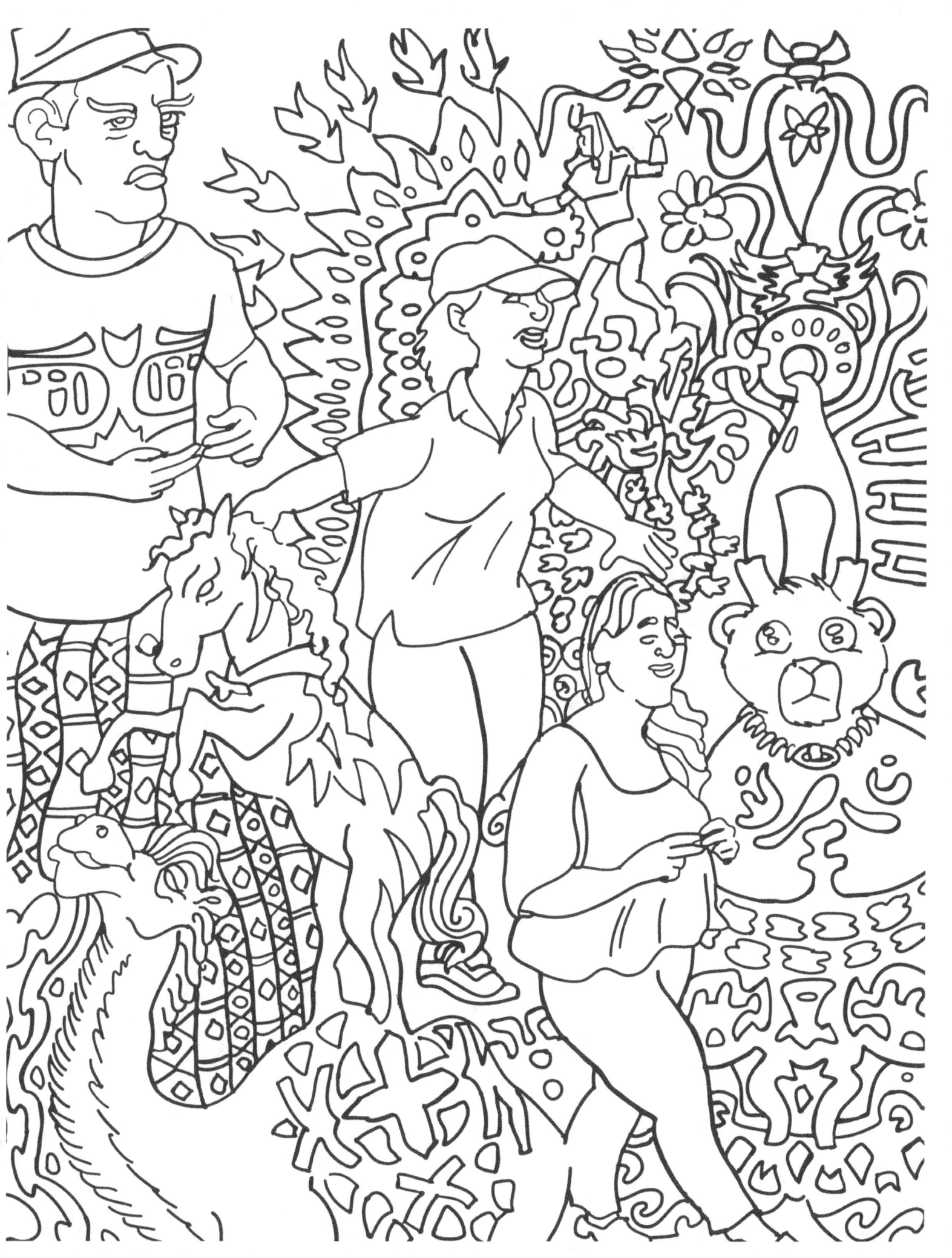

Murmuration

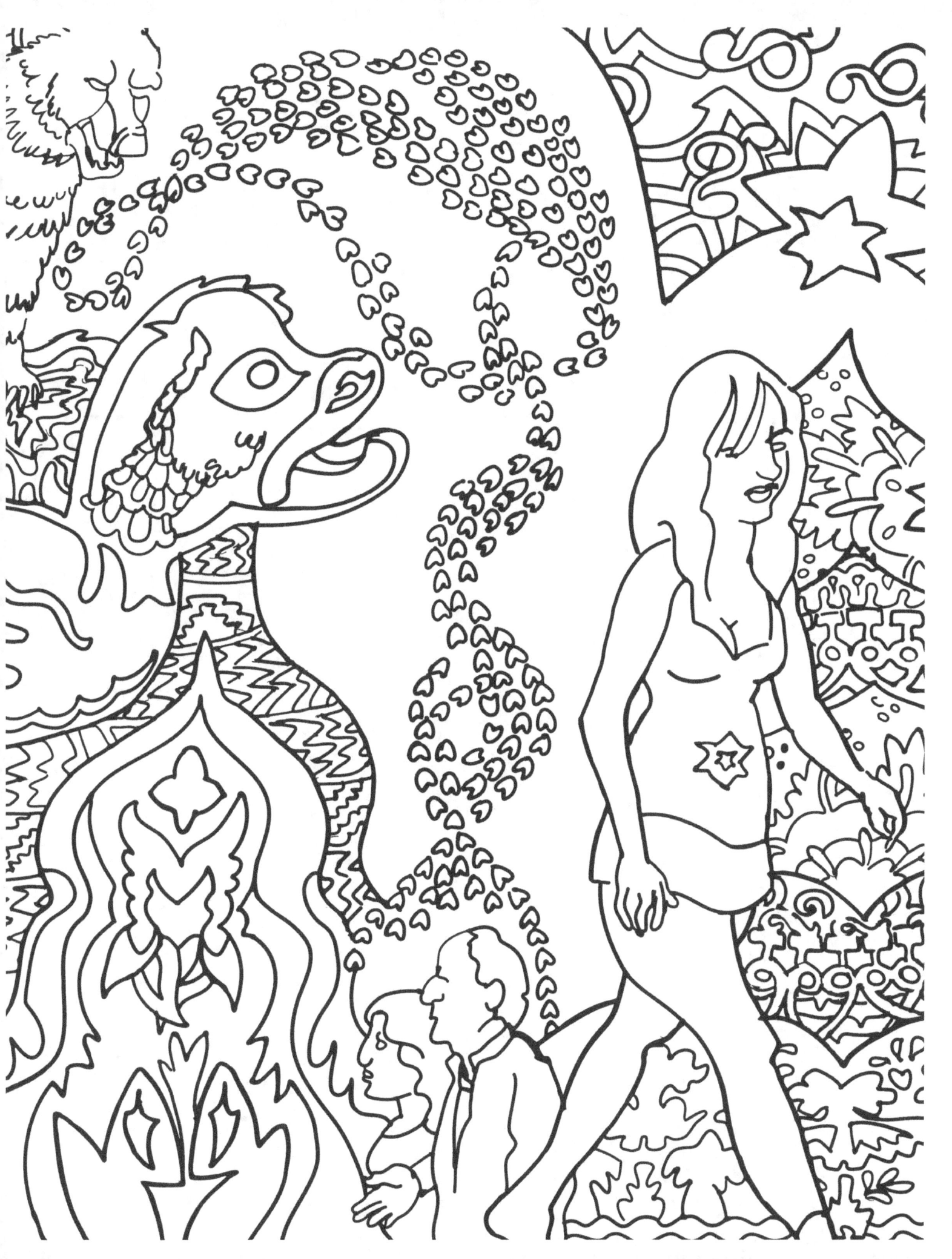

Quimbanda

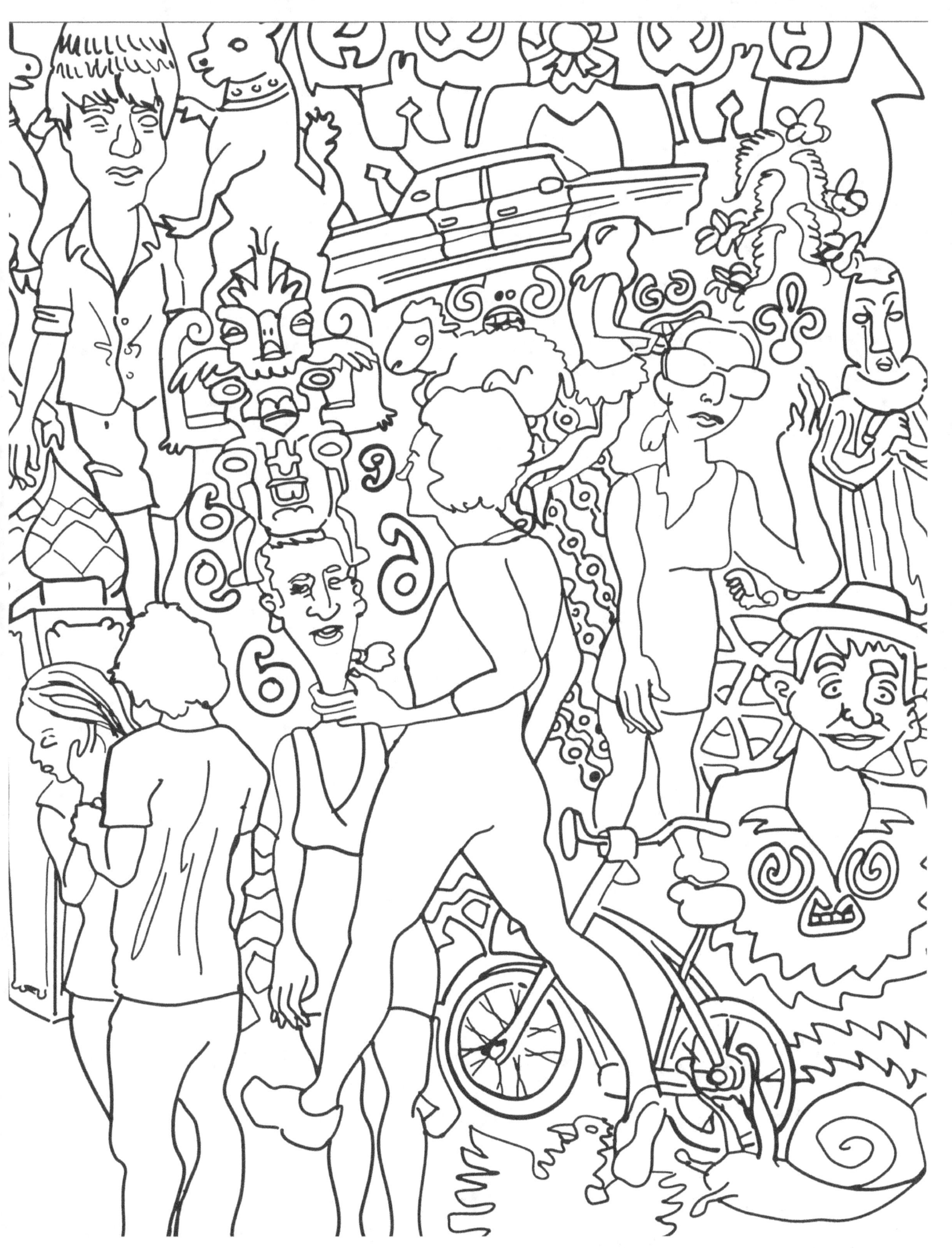

Scratch and Dent Loans

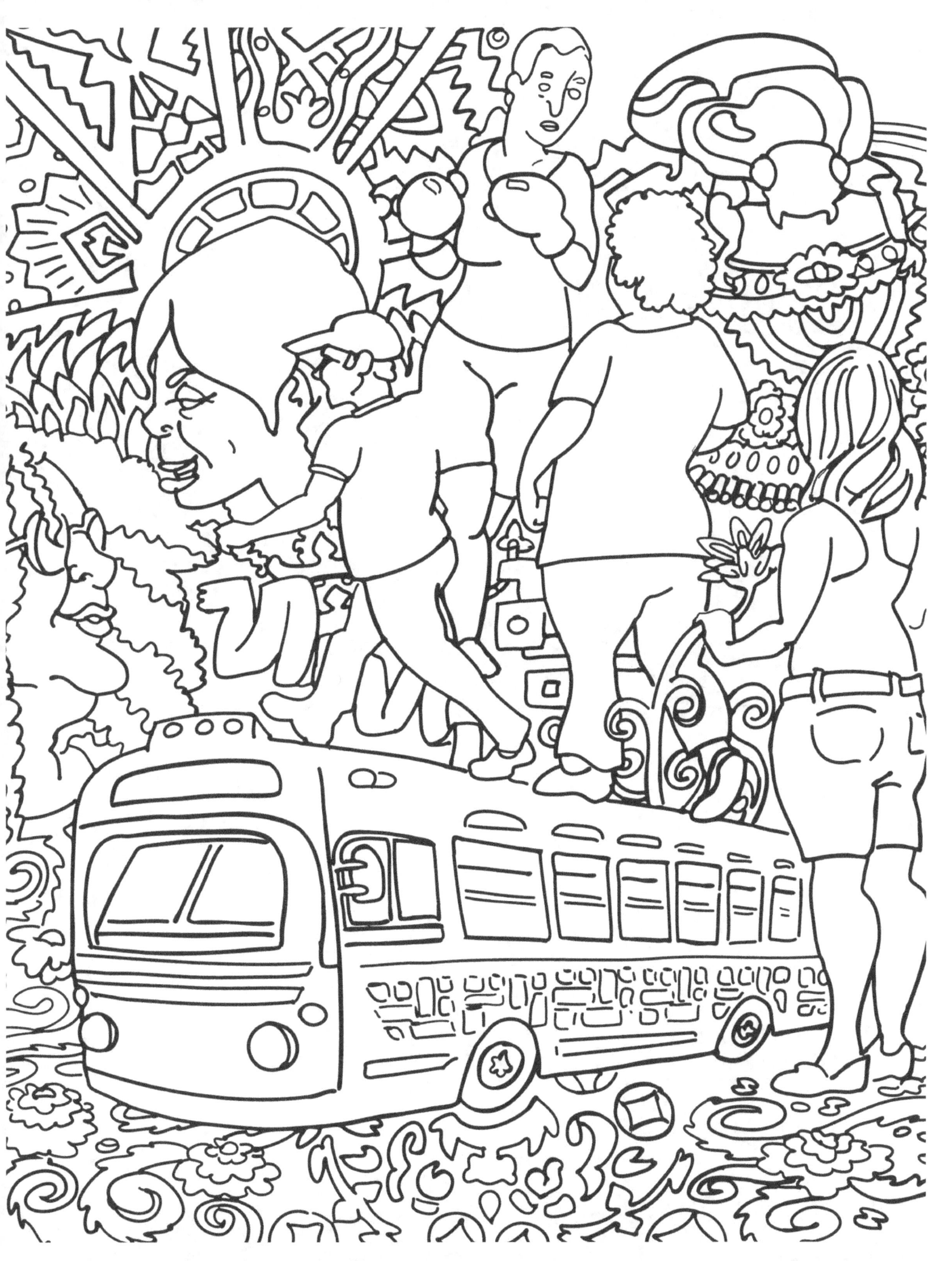

Insepulti

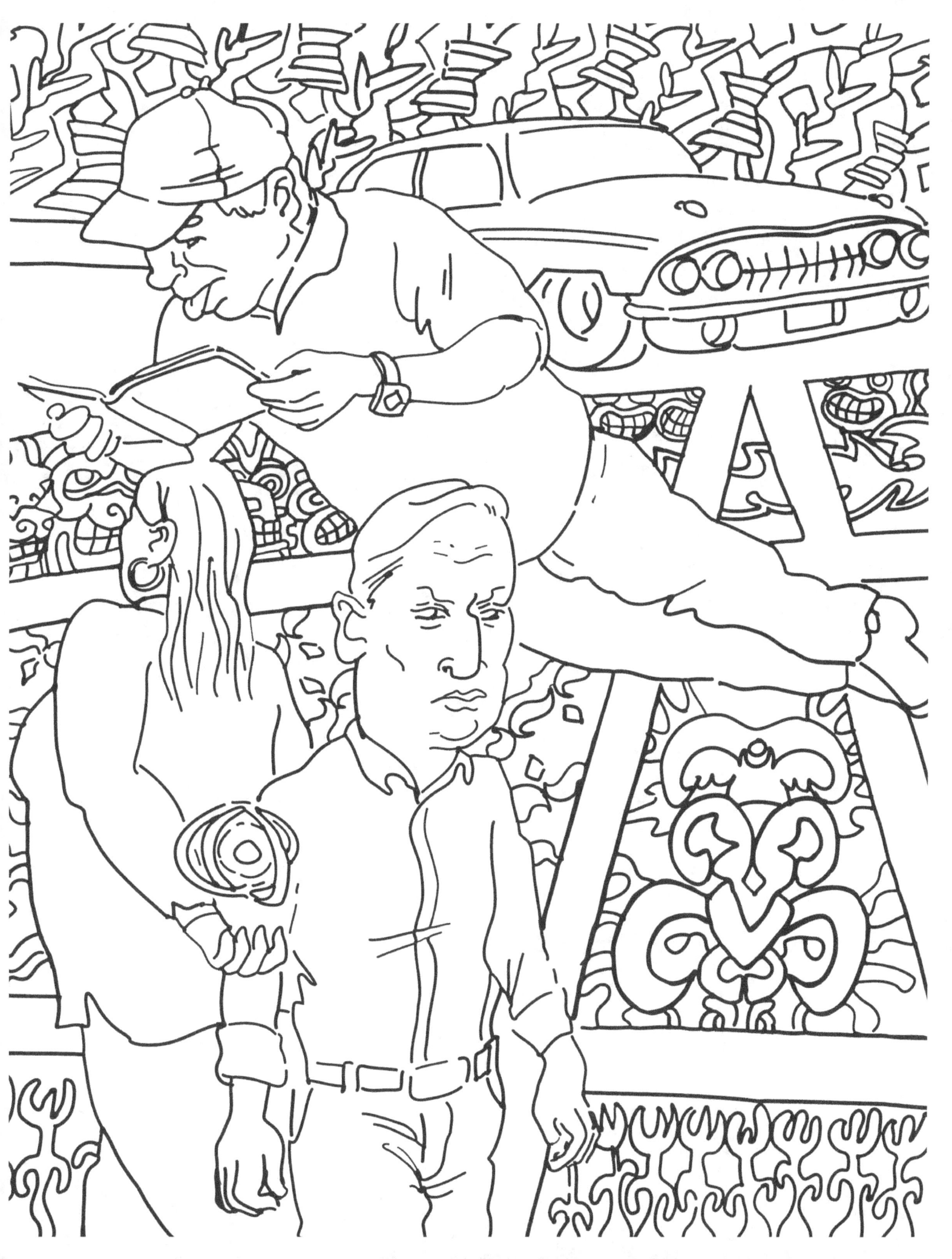

Ringwoodite

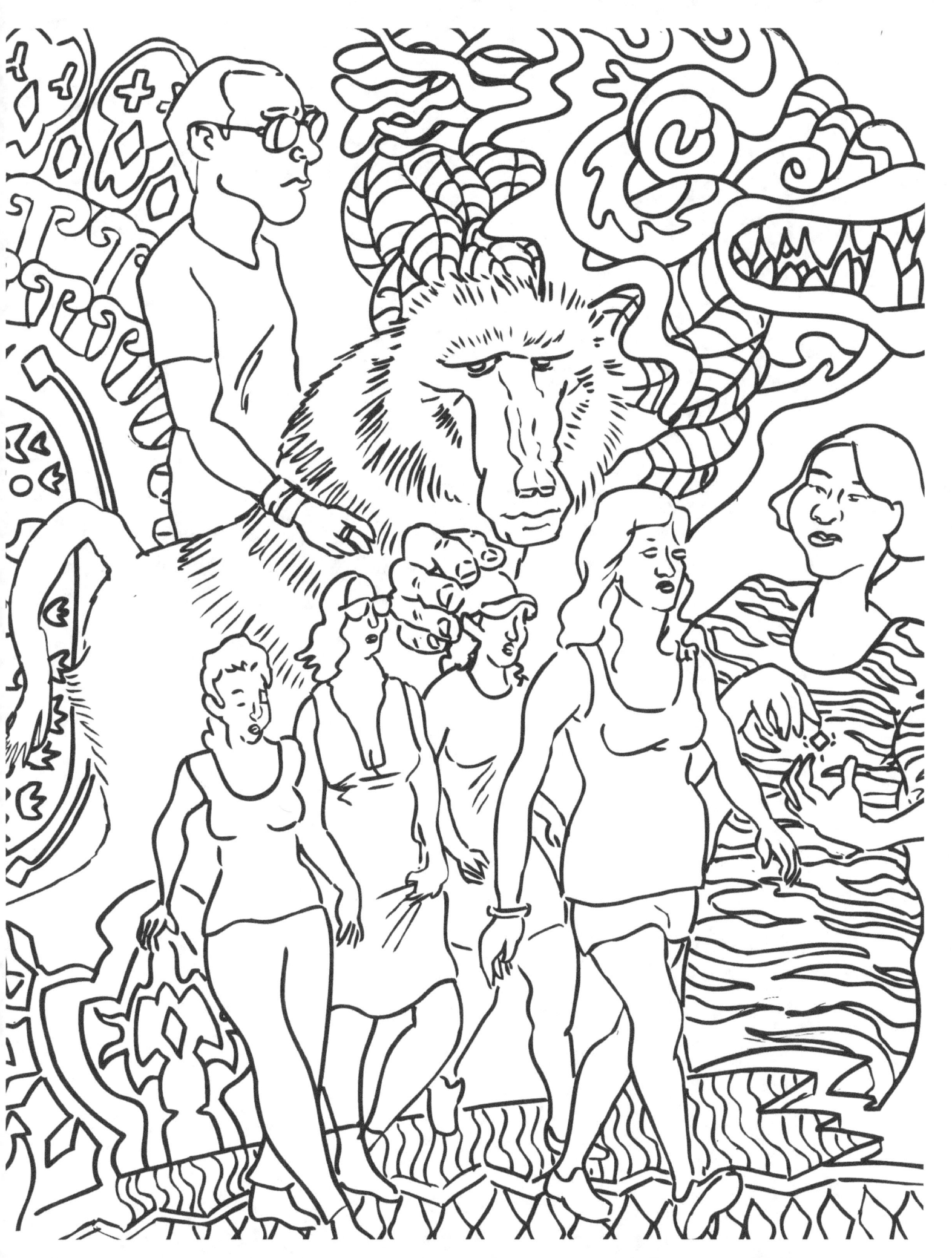

Sabacurinca

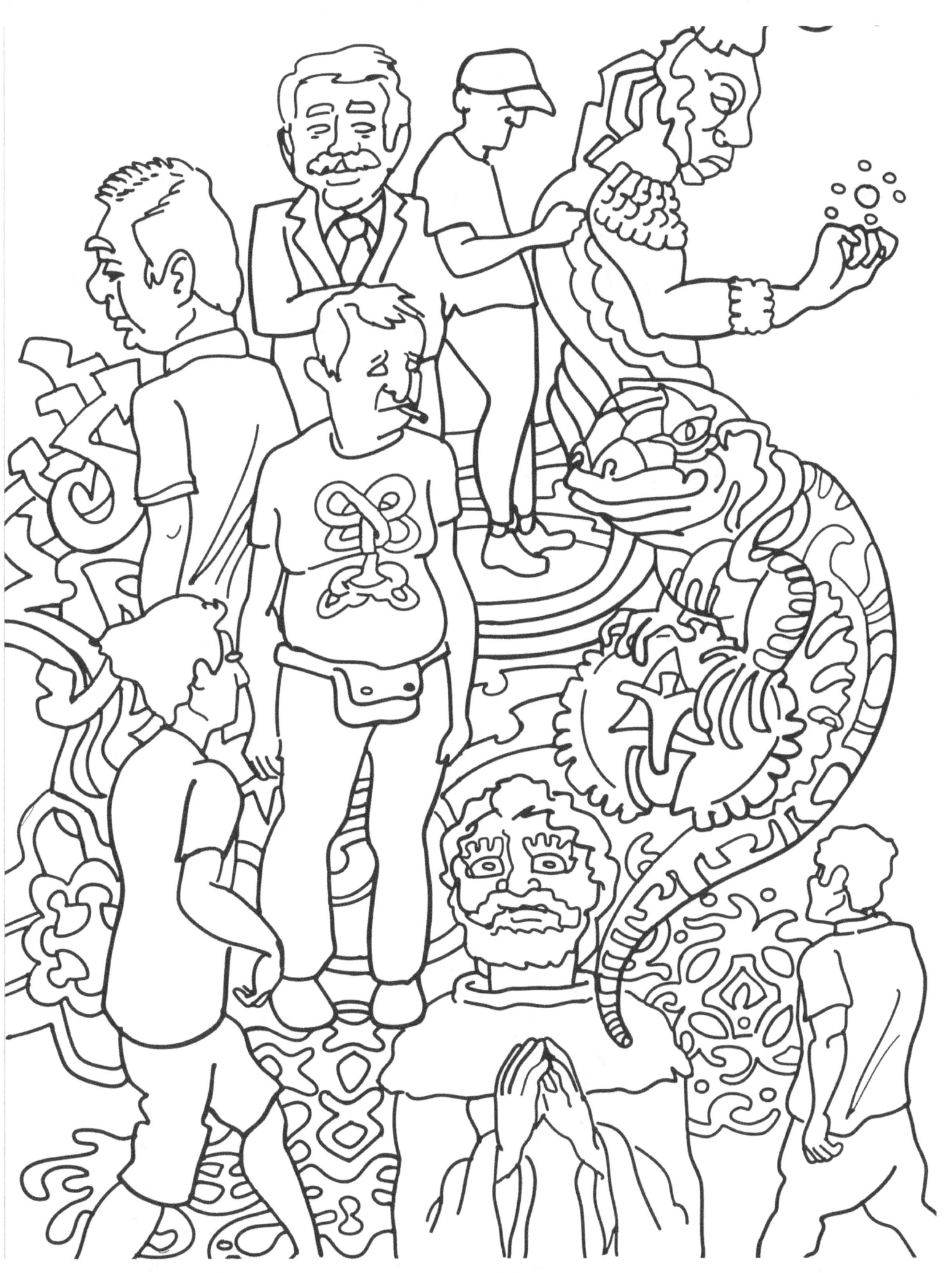

Vital Current

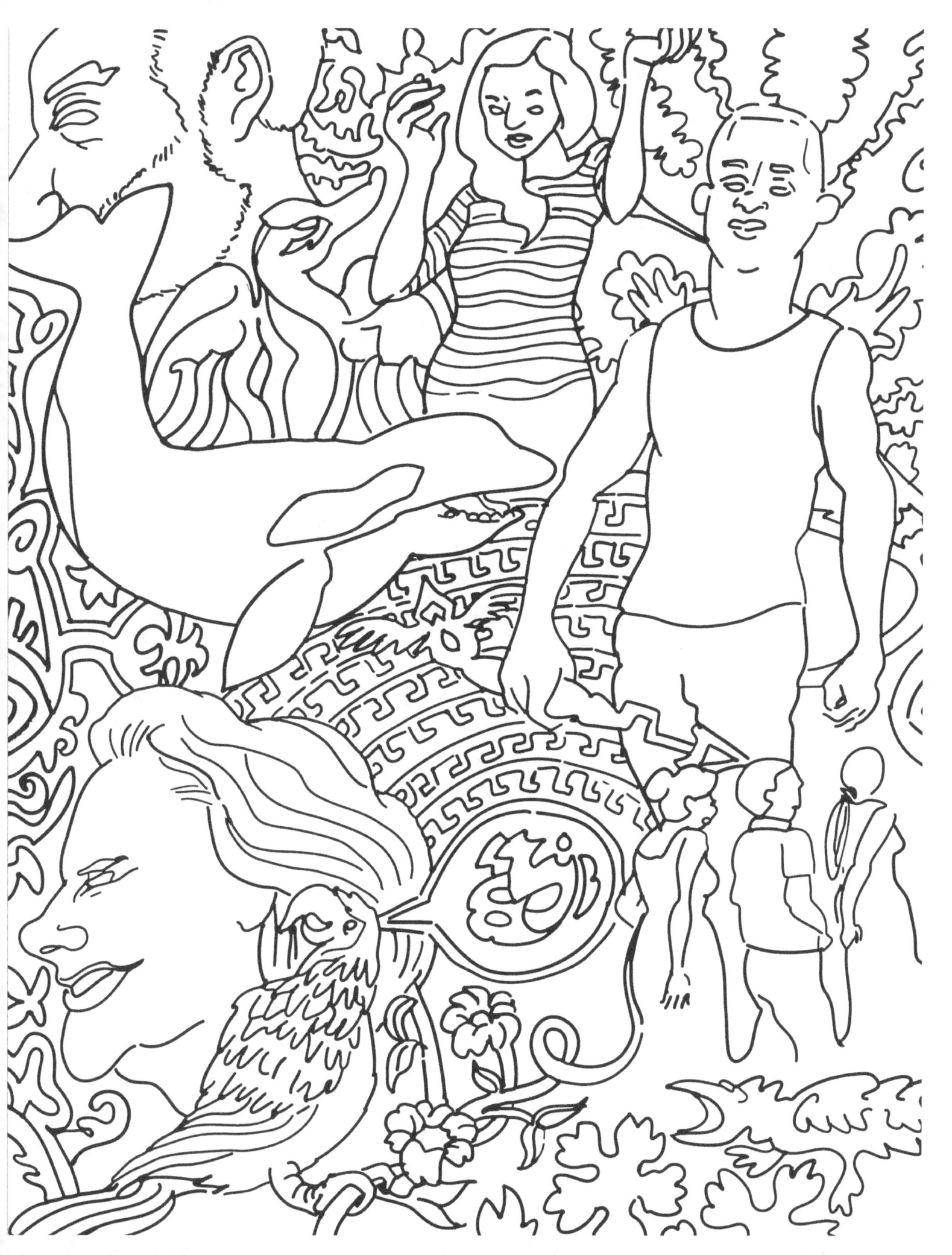

Max Flow

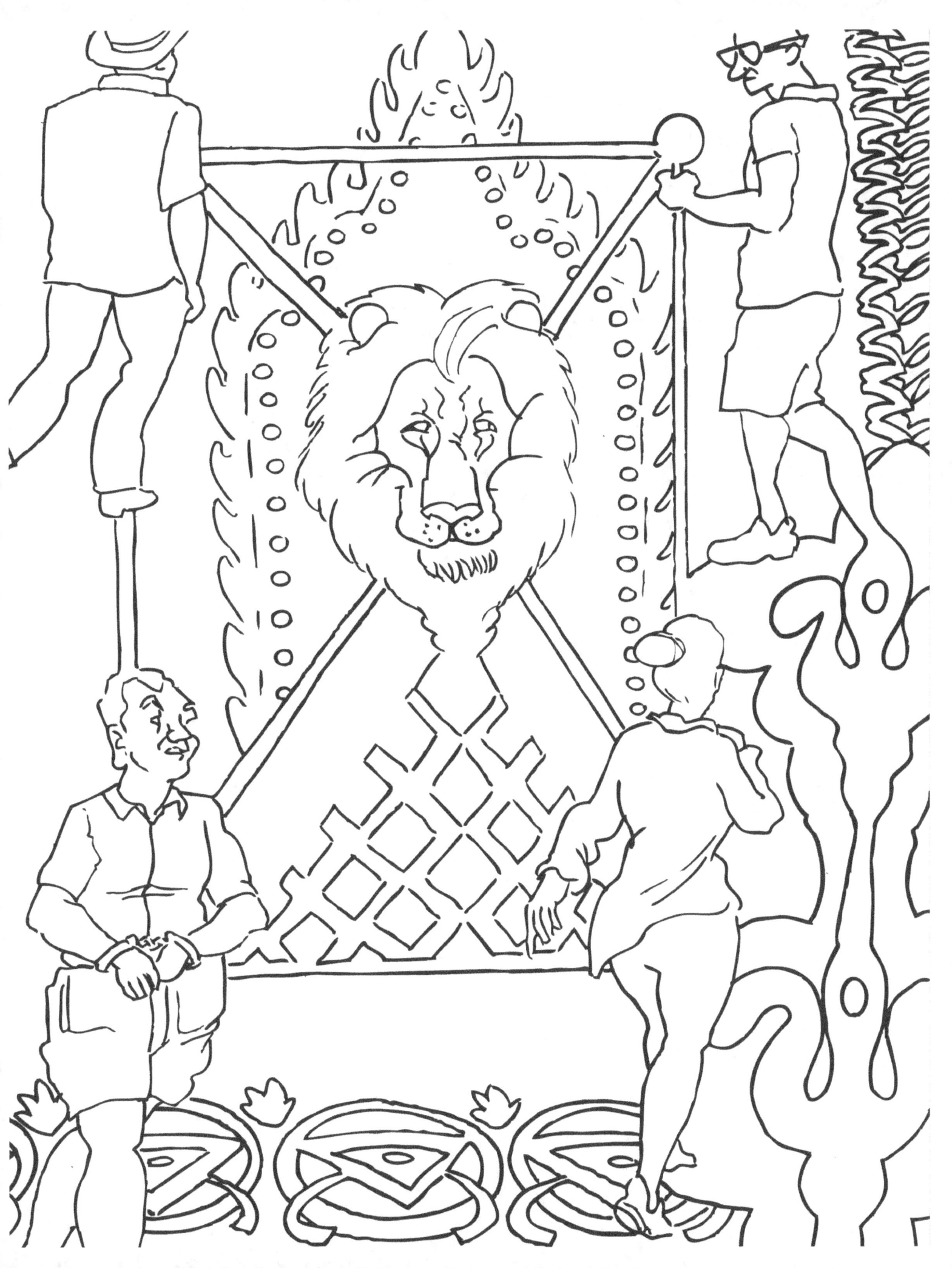

Pindamonhangaba

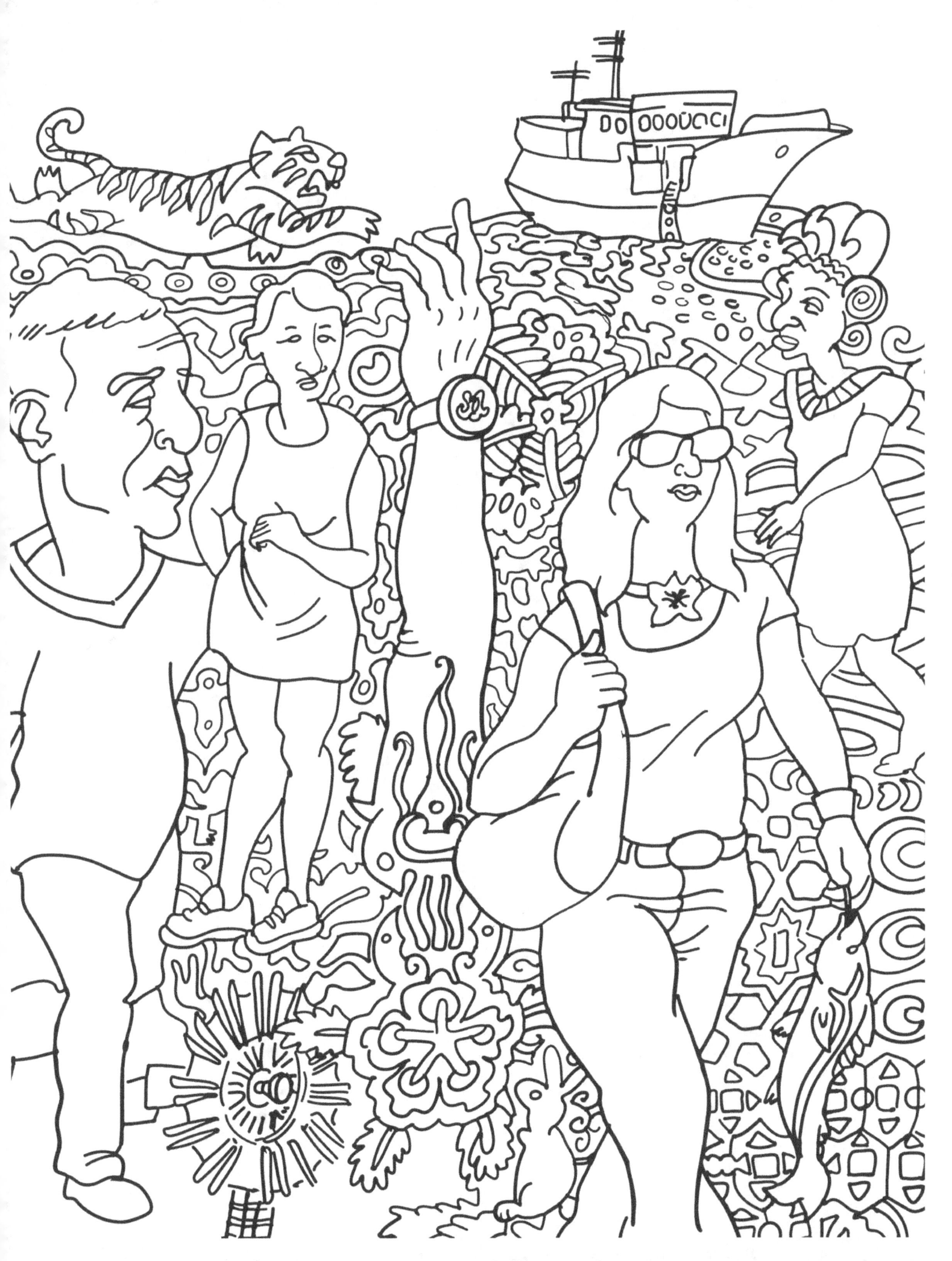

Myelination

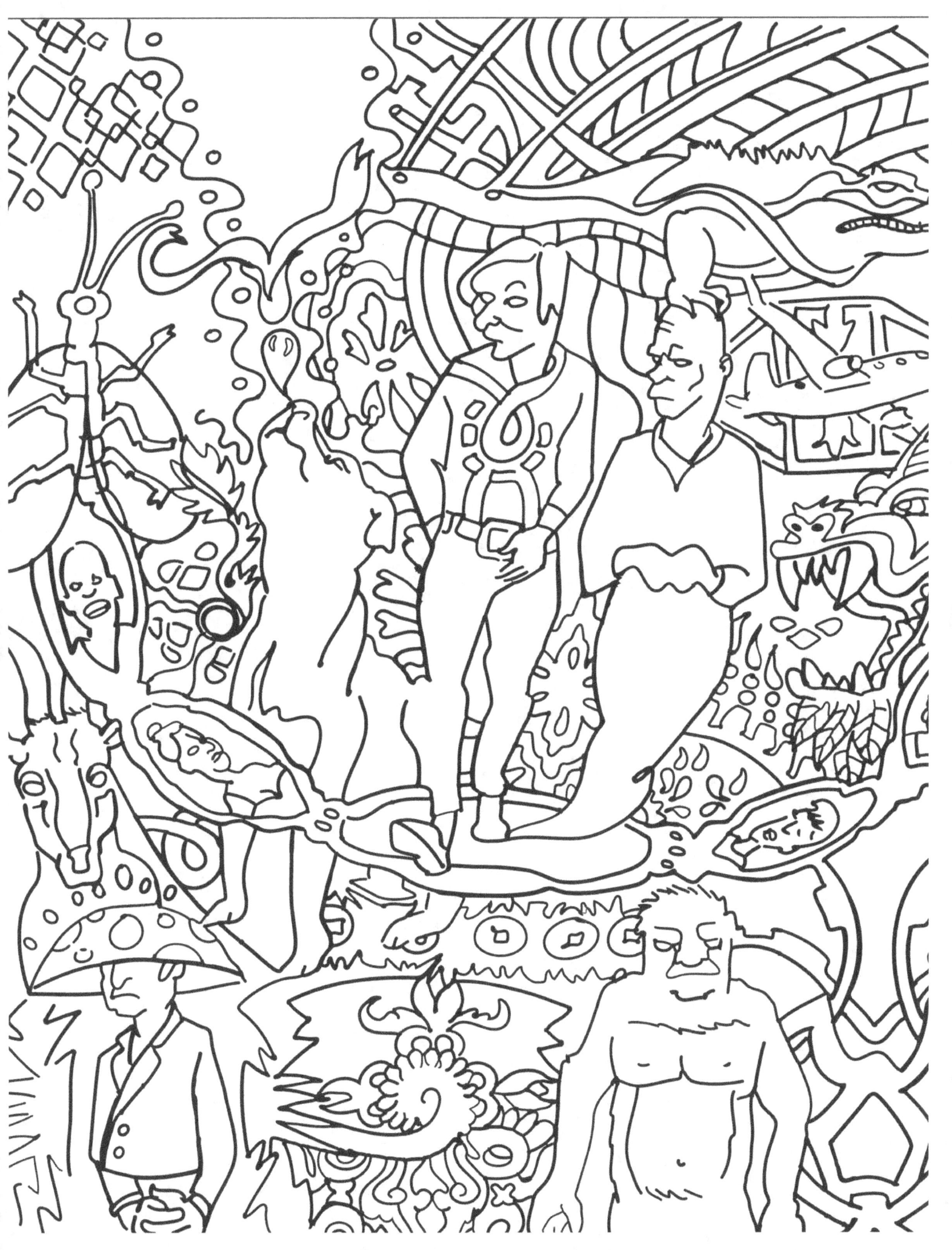

Outsanity

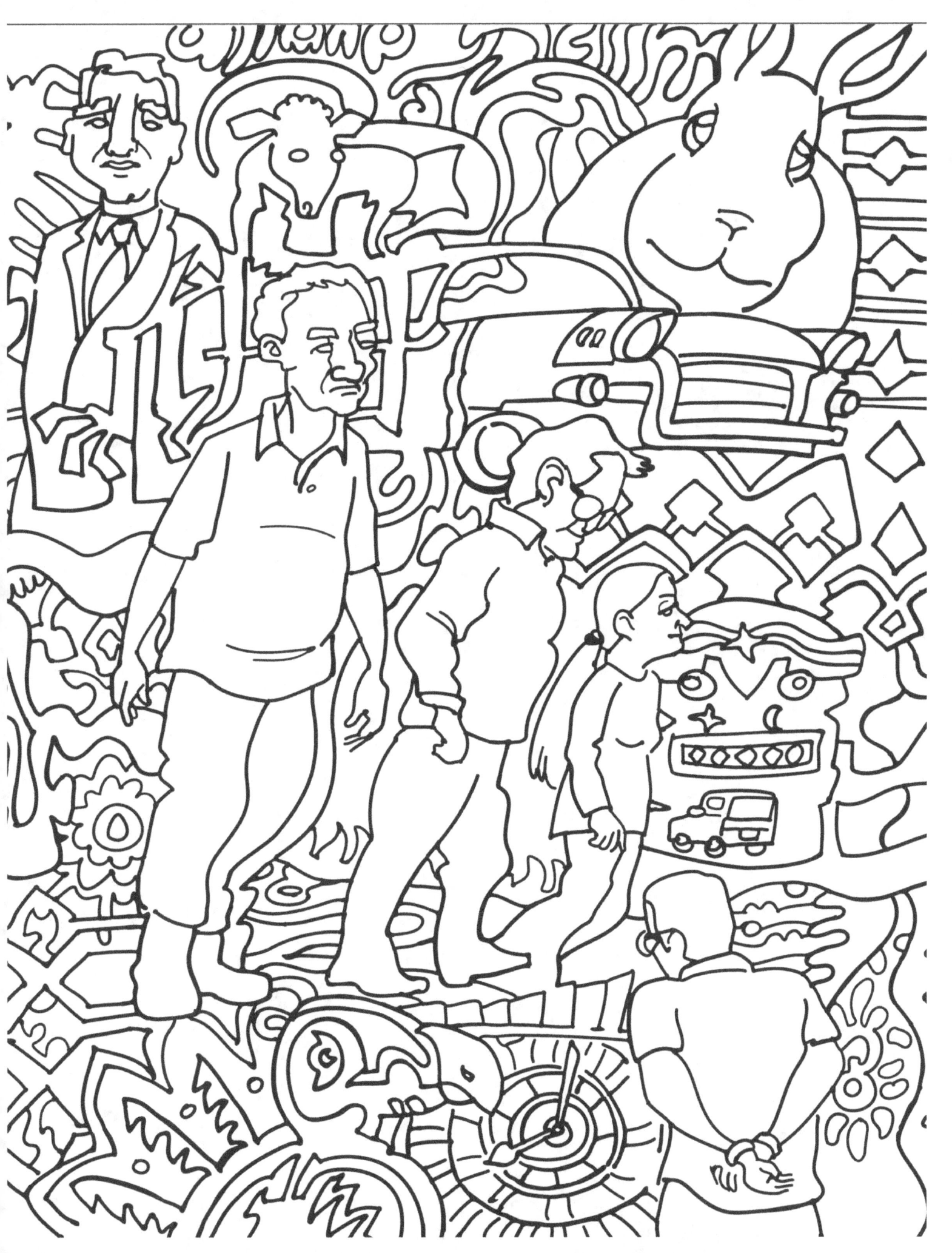

Tortionfield

Feraferia

Pluripotent

Veridical Hallucination

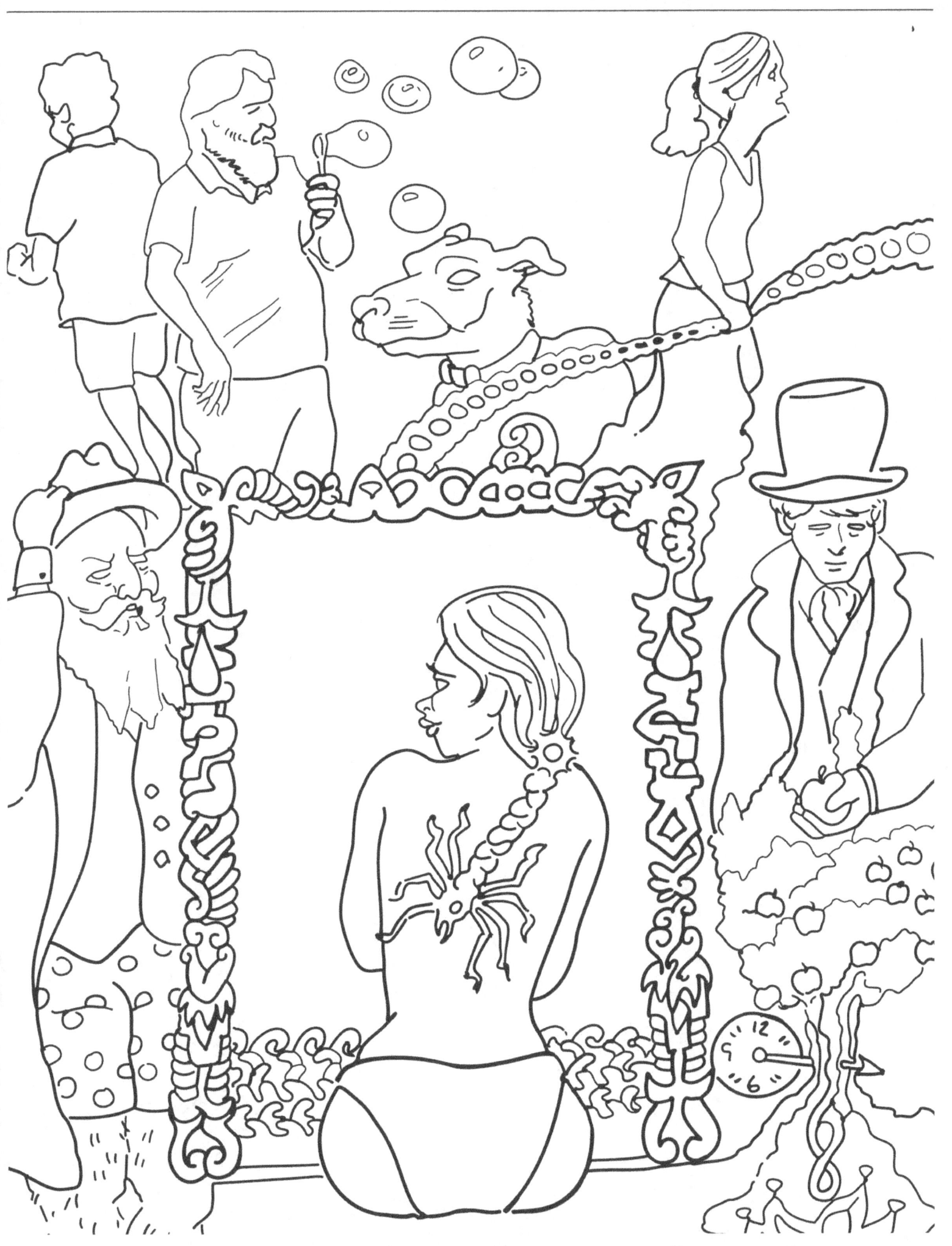

Malphrus

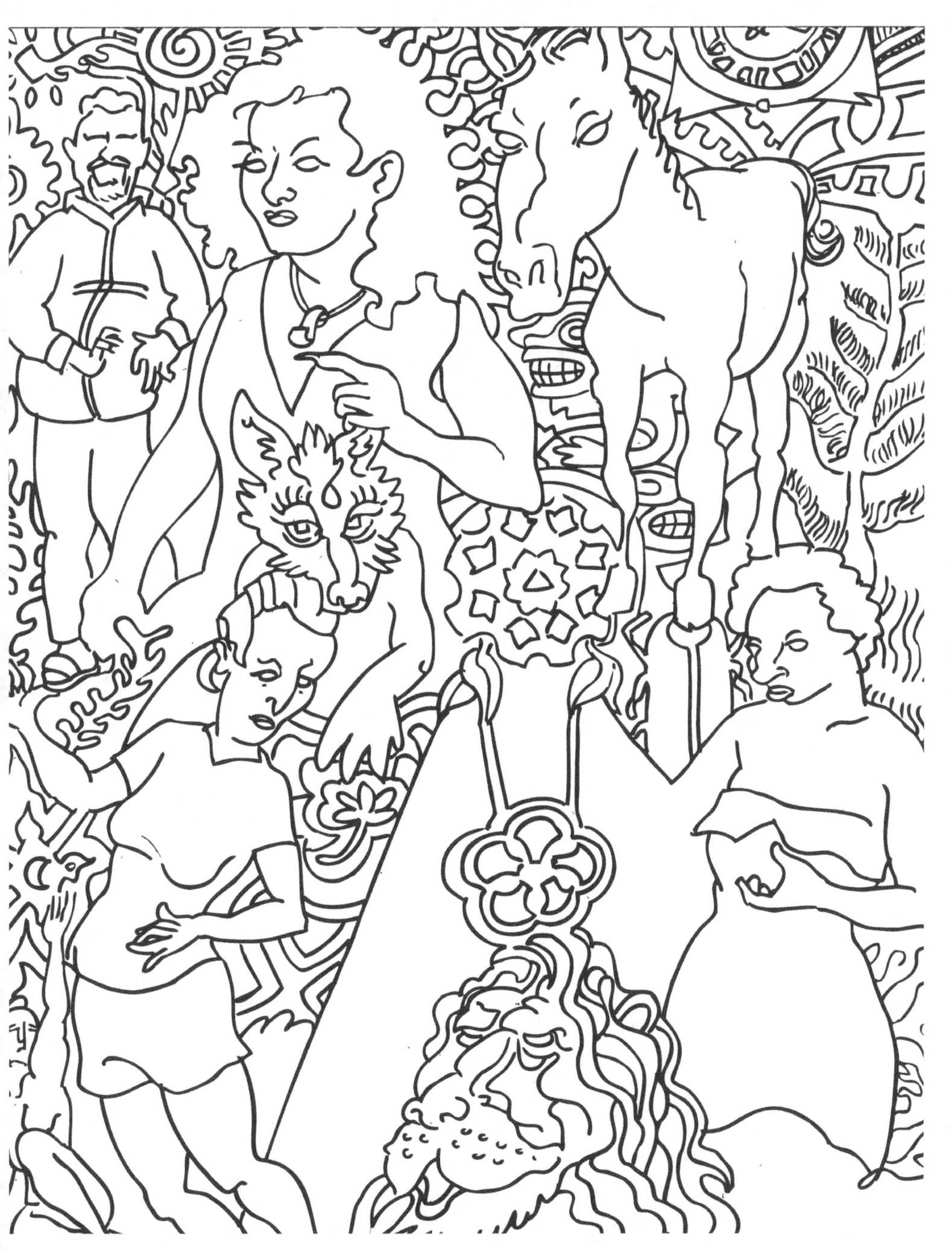

Naqsh-i-Rustam

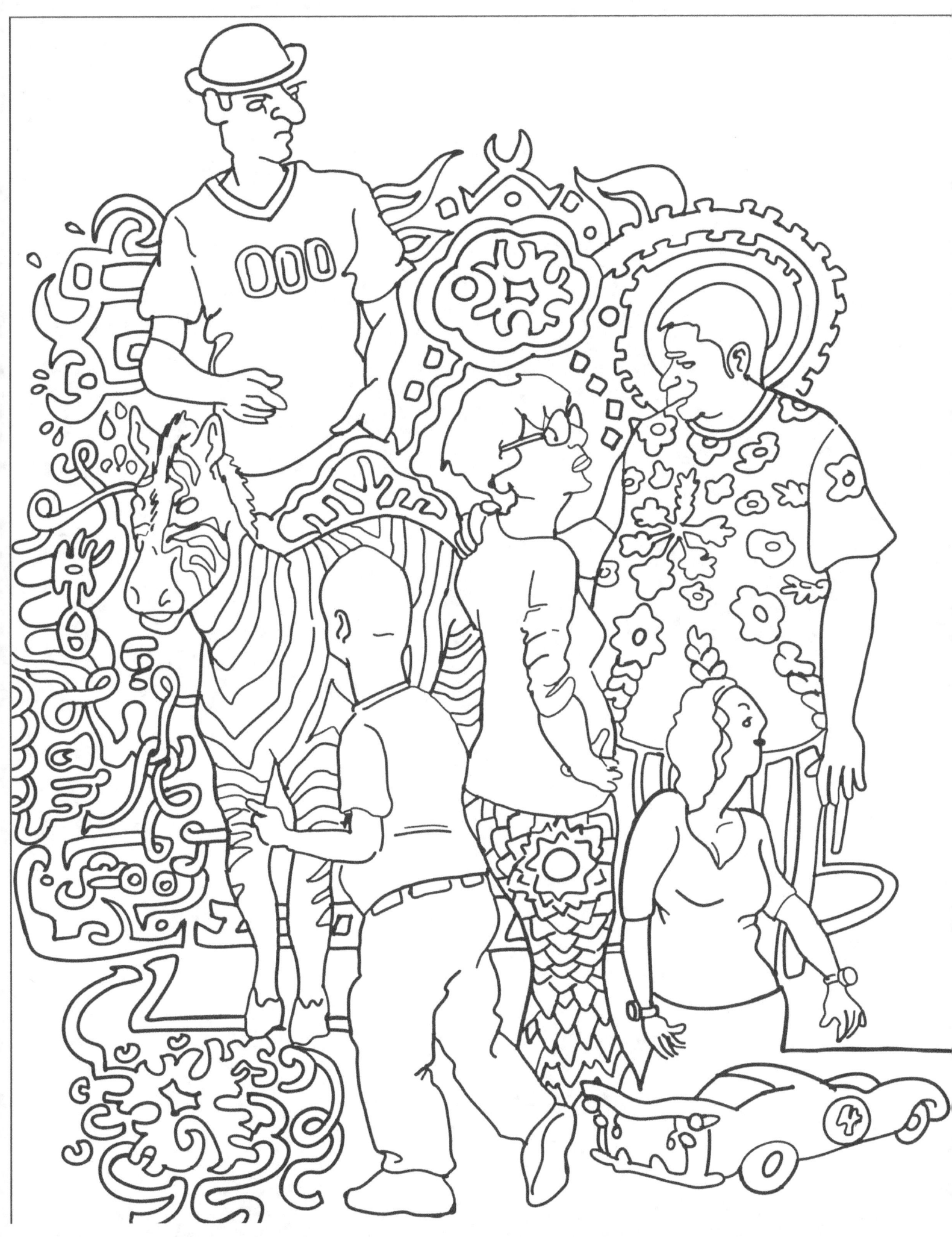

Computable General Equalibrium

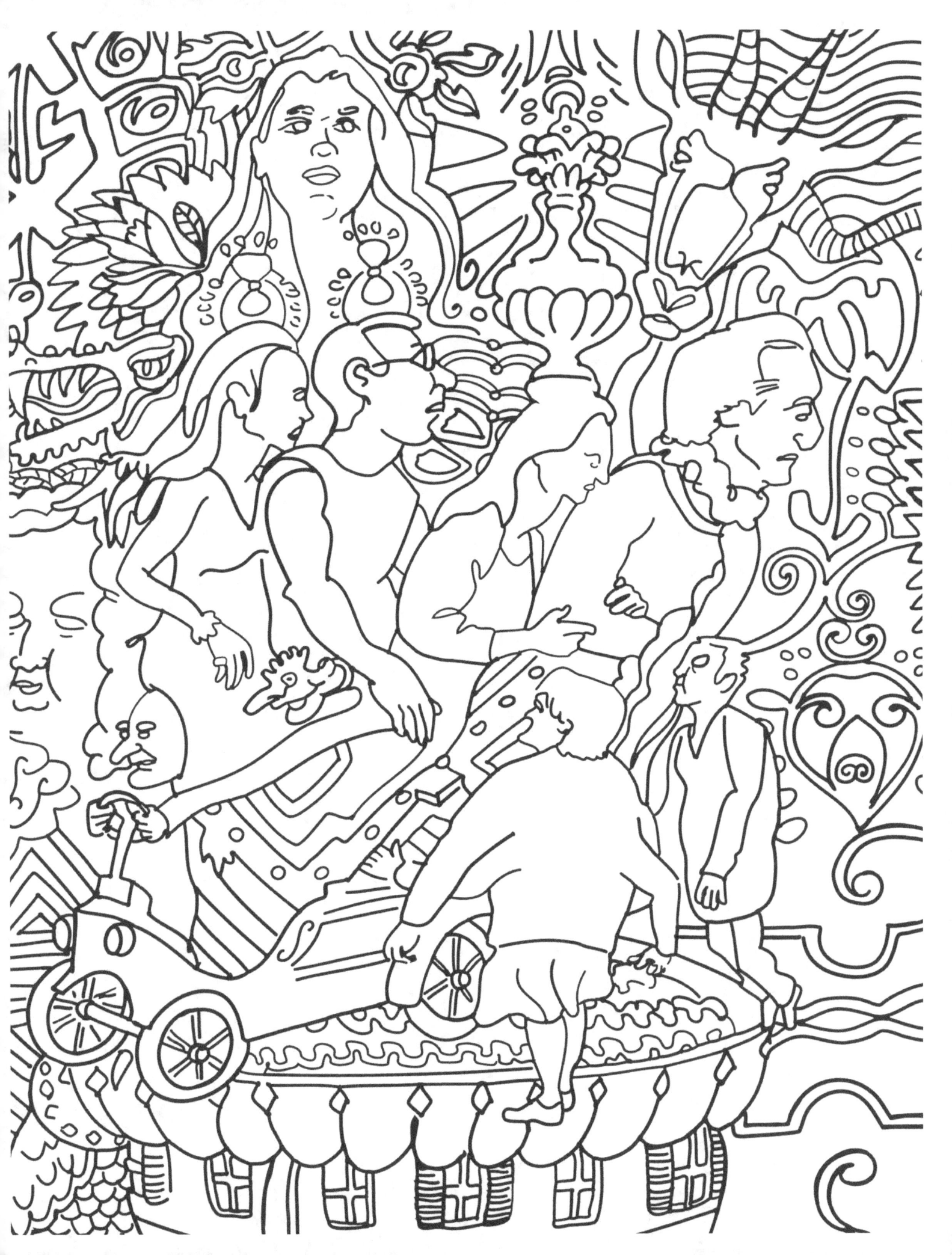

Saccharo

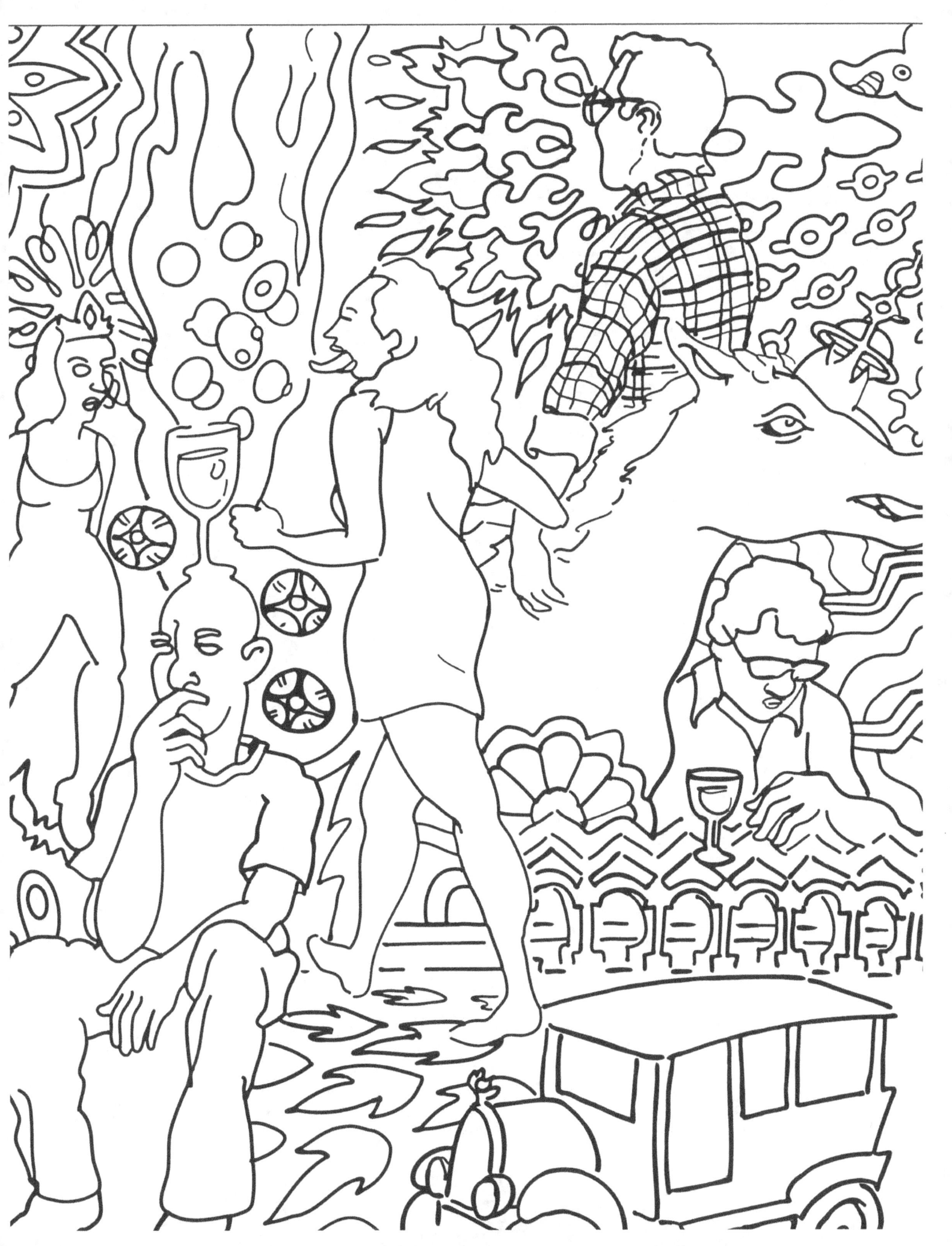

Trypophobia

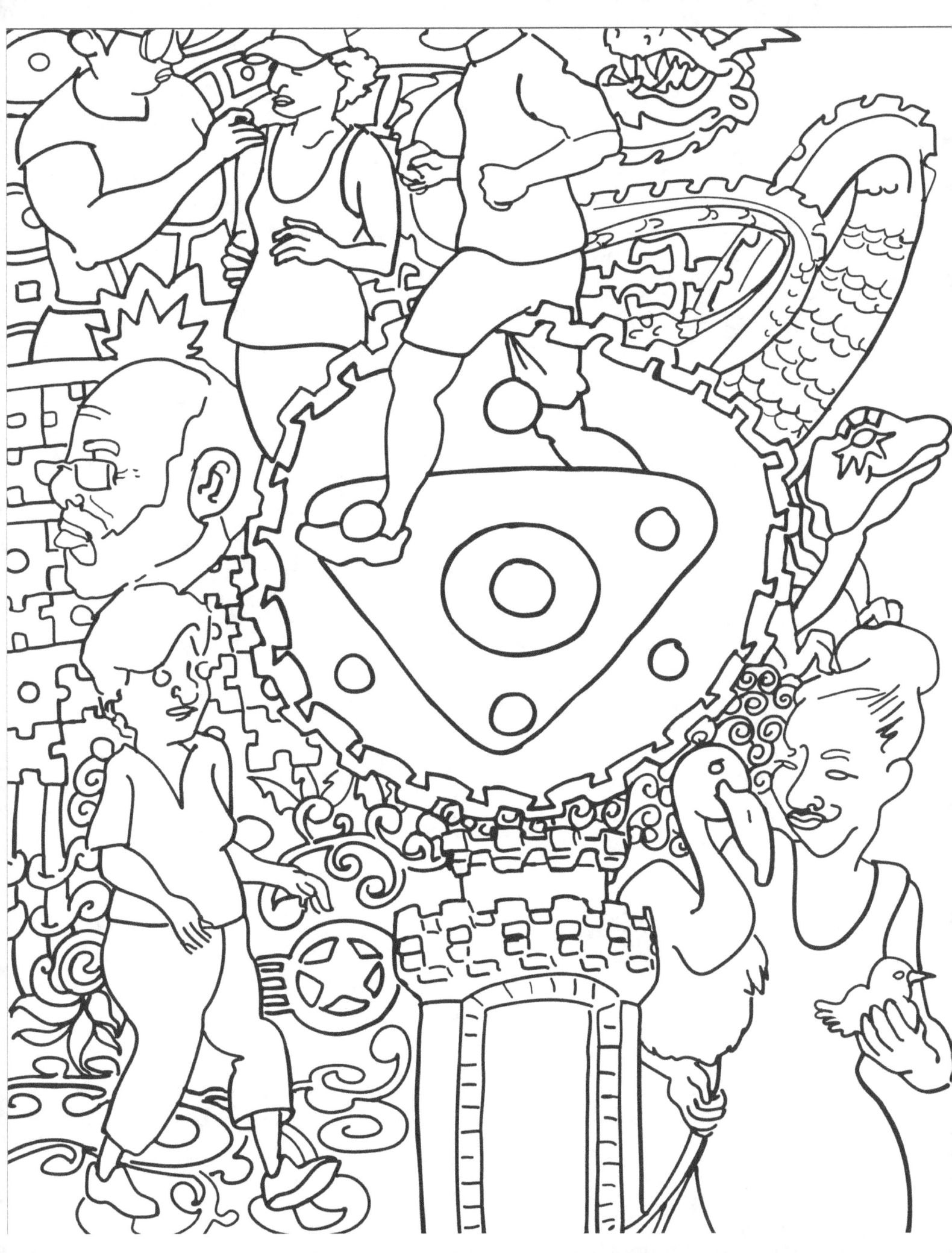

Cosmodrome

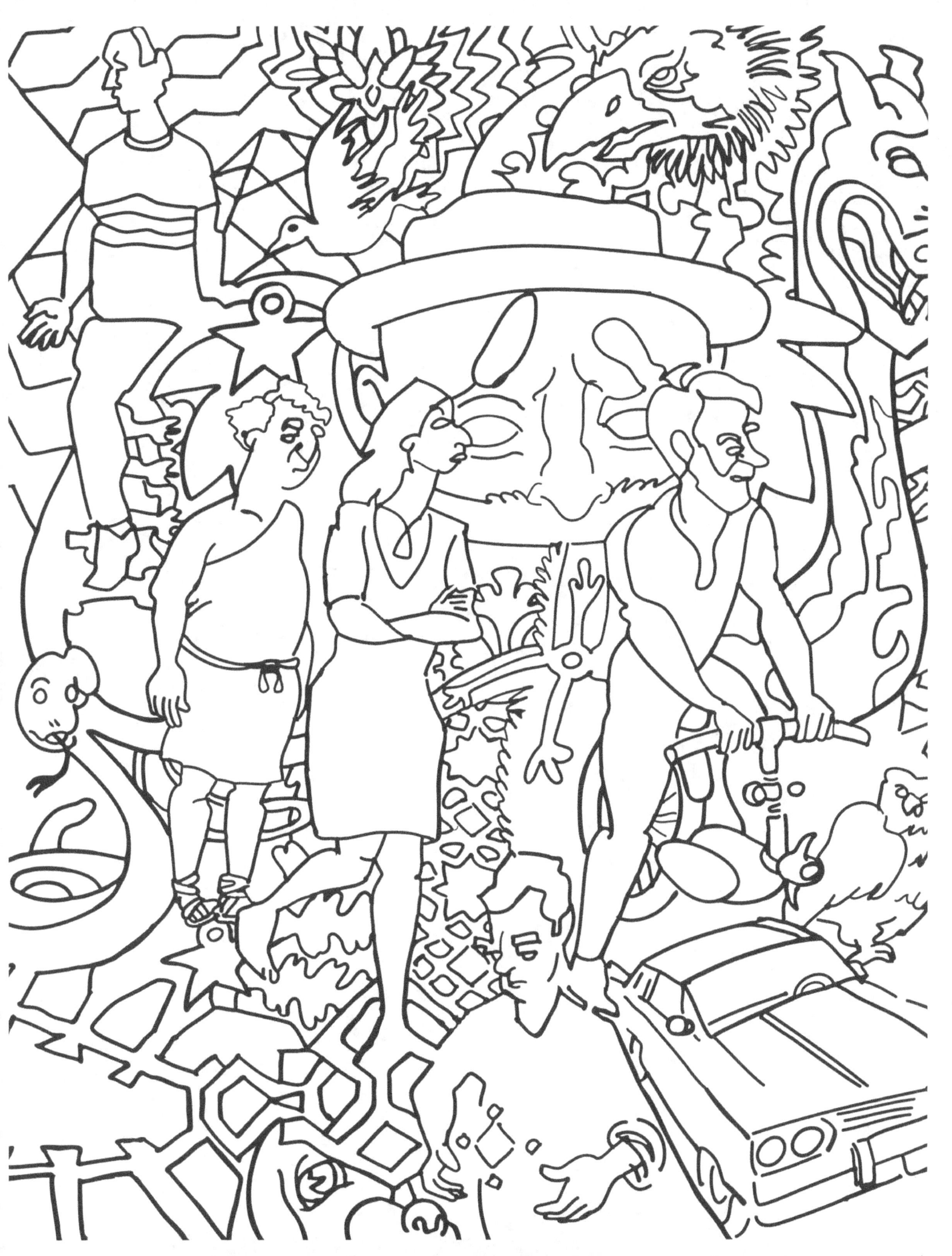

Kryptodrakon

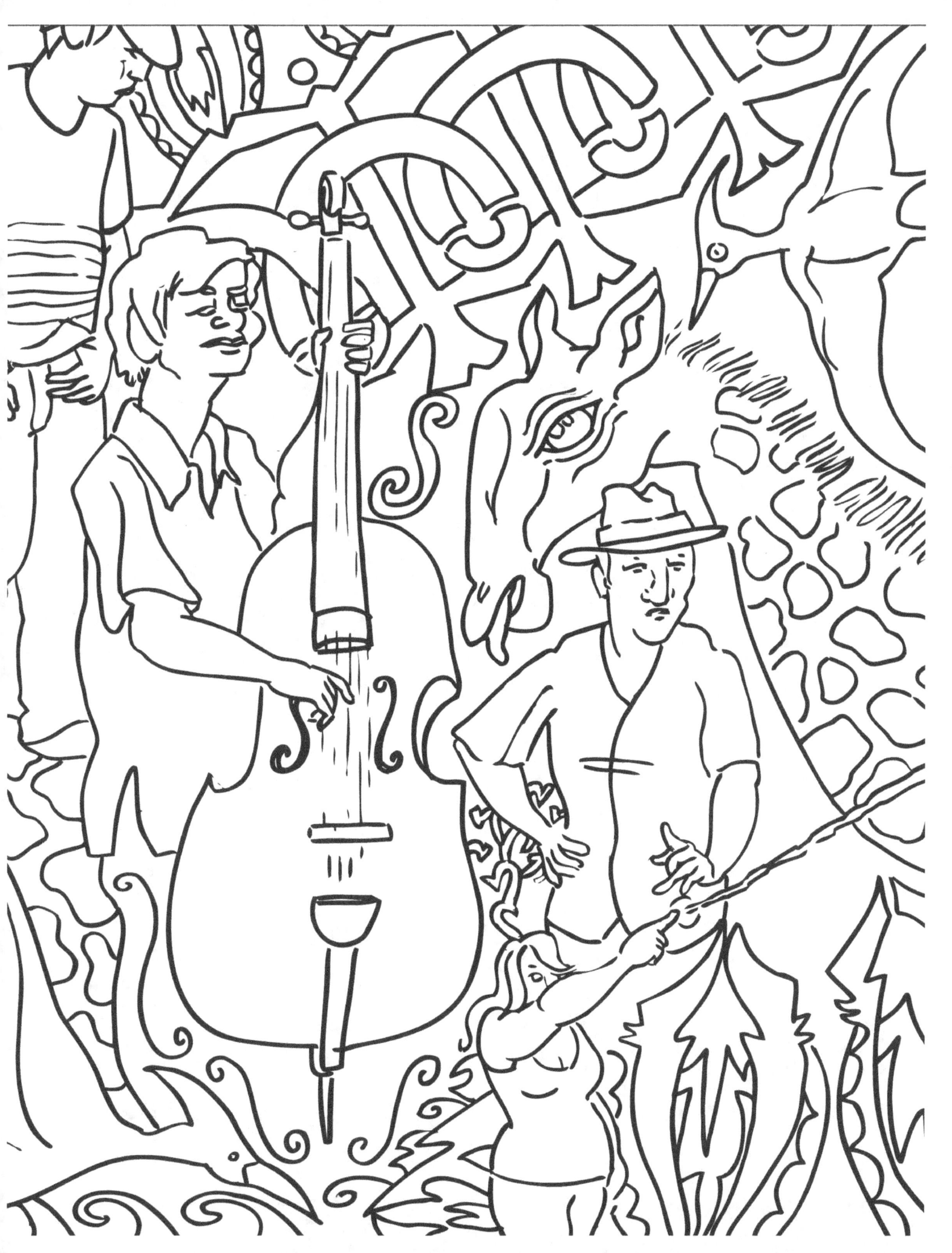

Lady of Linshui

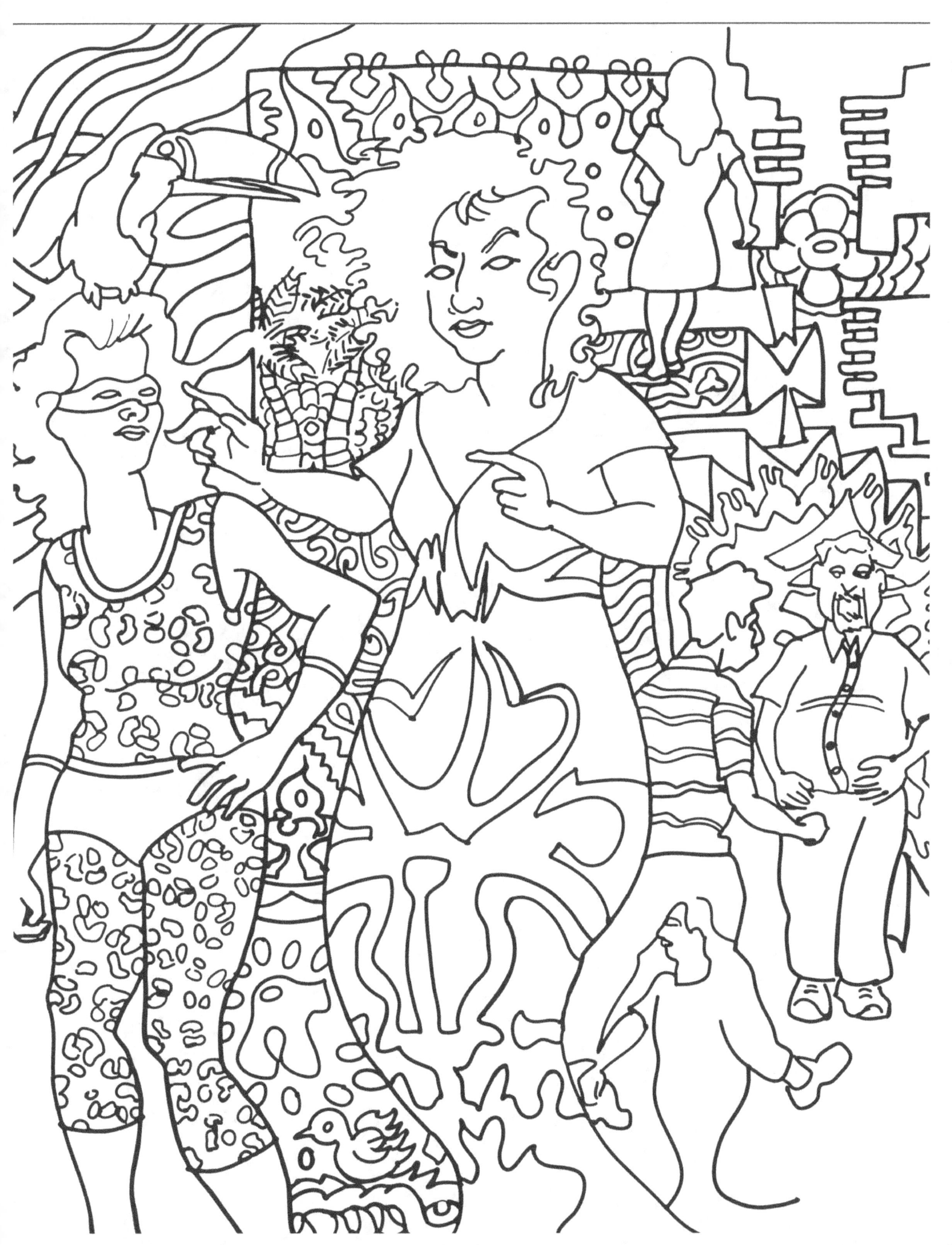

Spirit Lodge

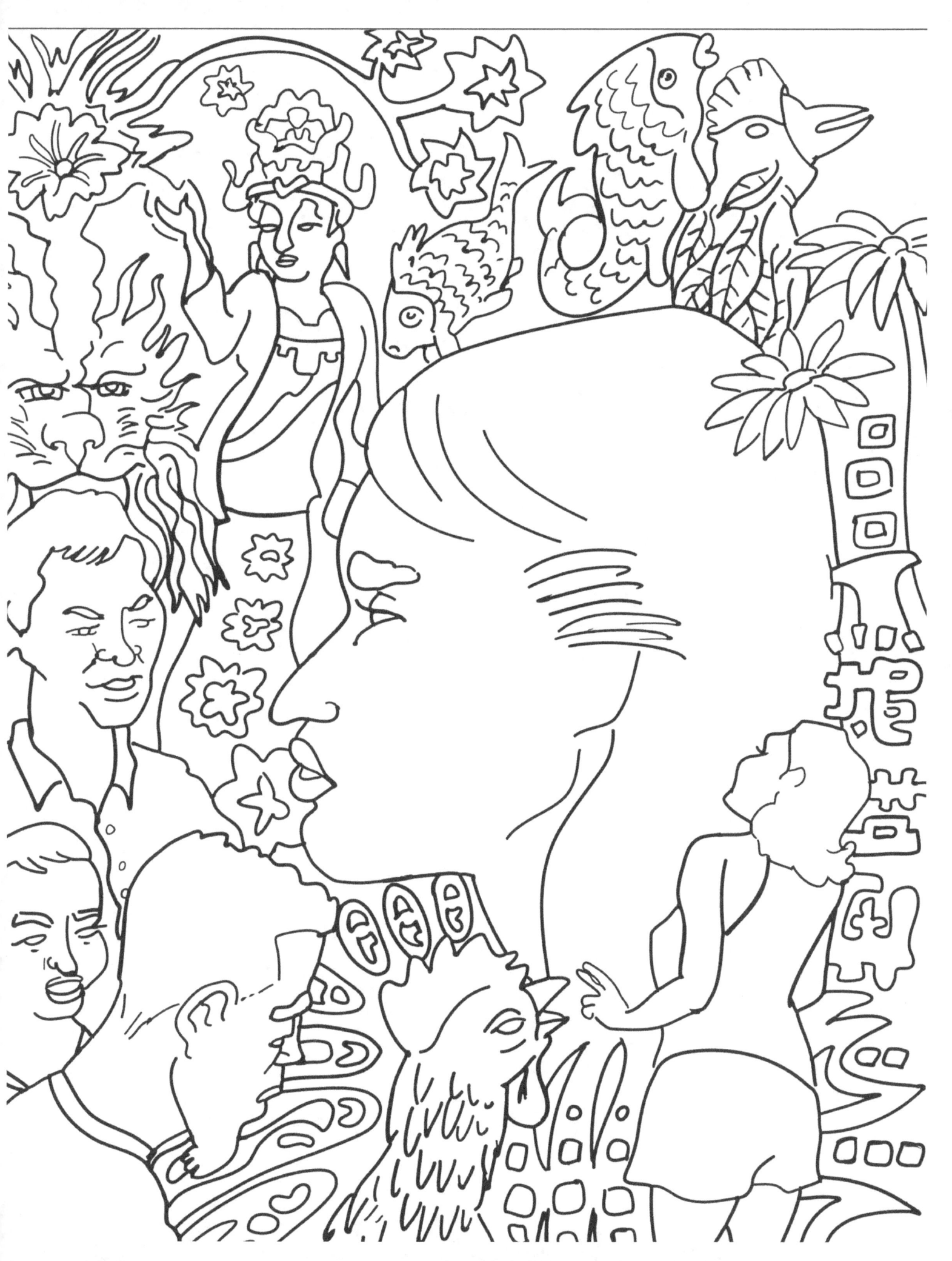

Tiktaalik Roseae

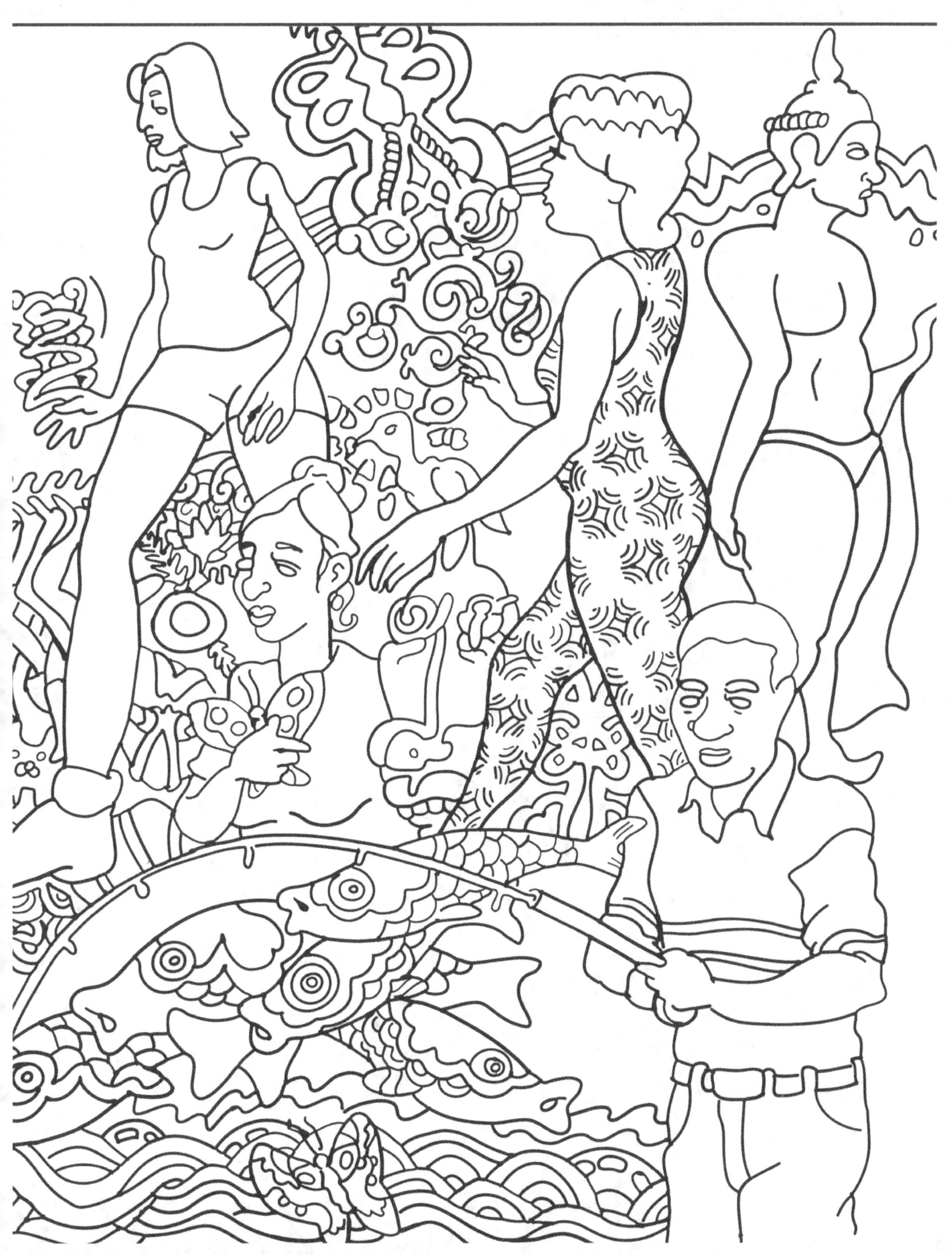

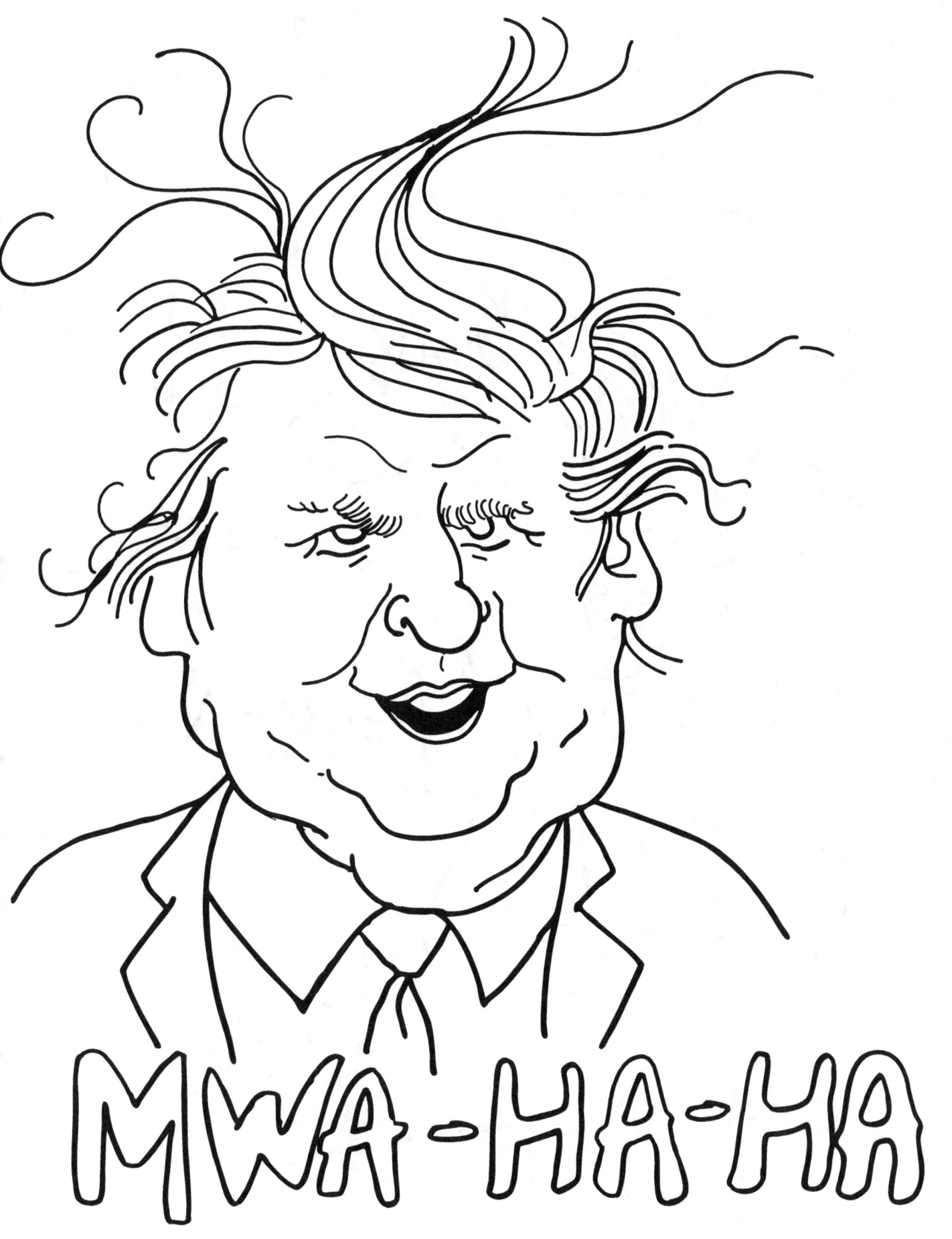

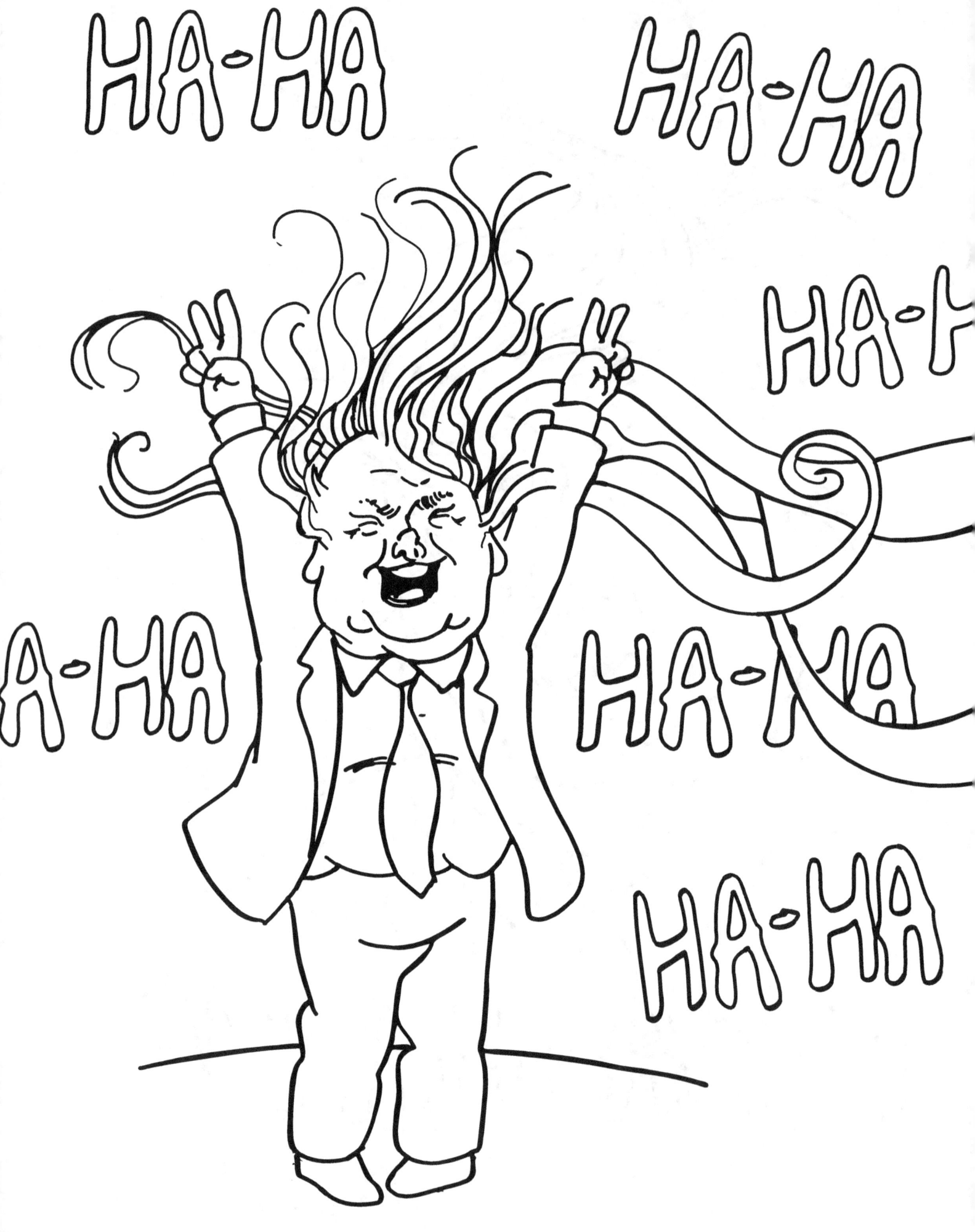

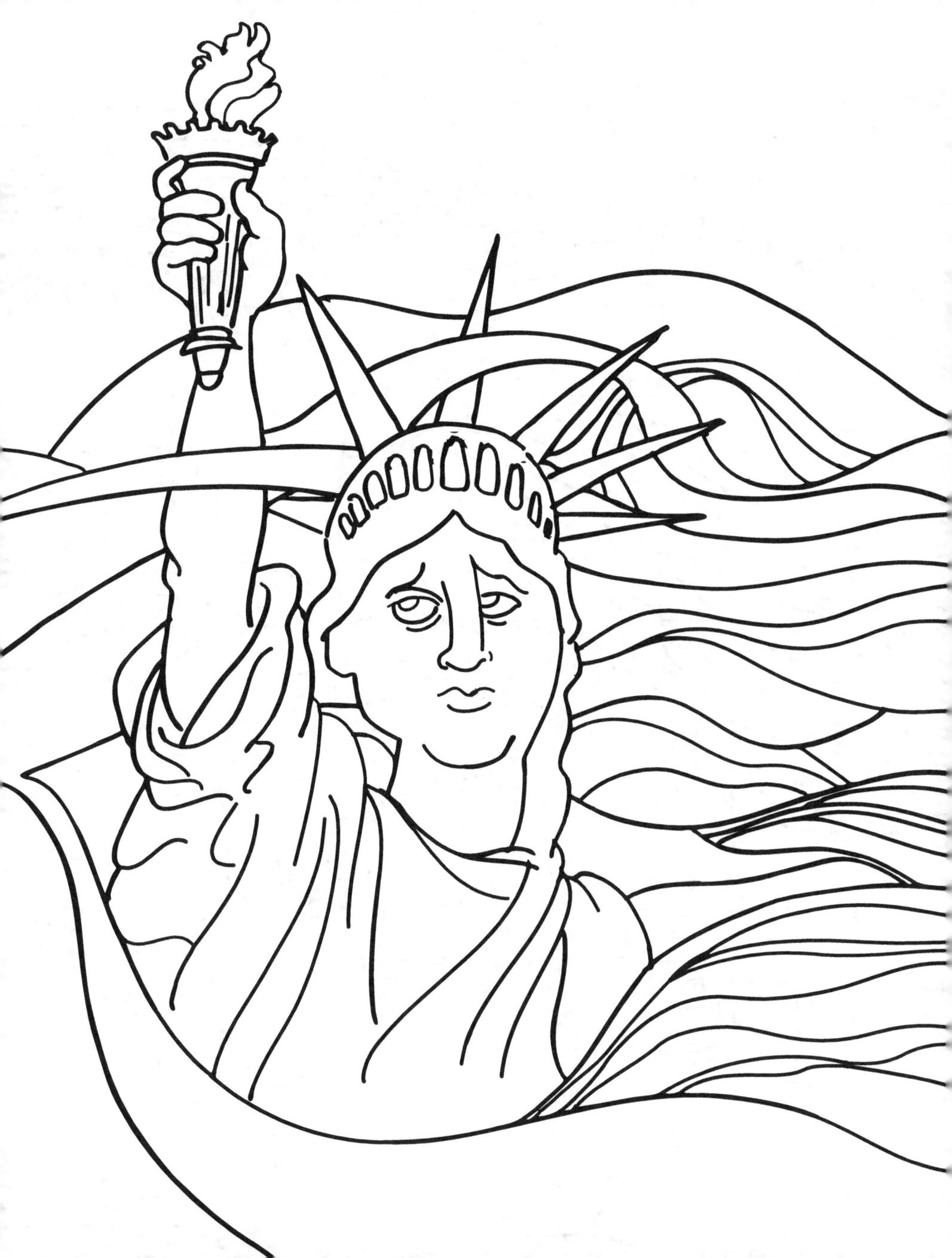

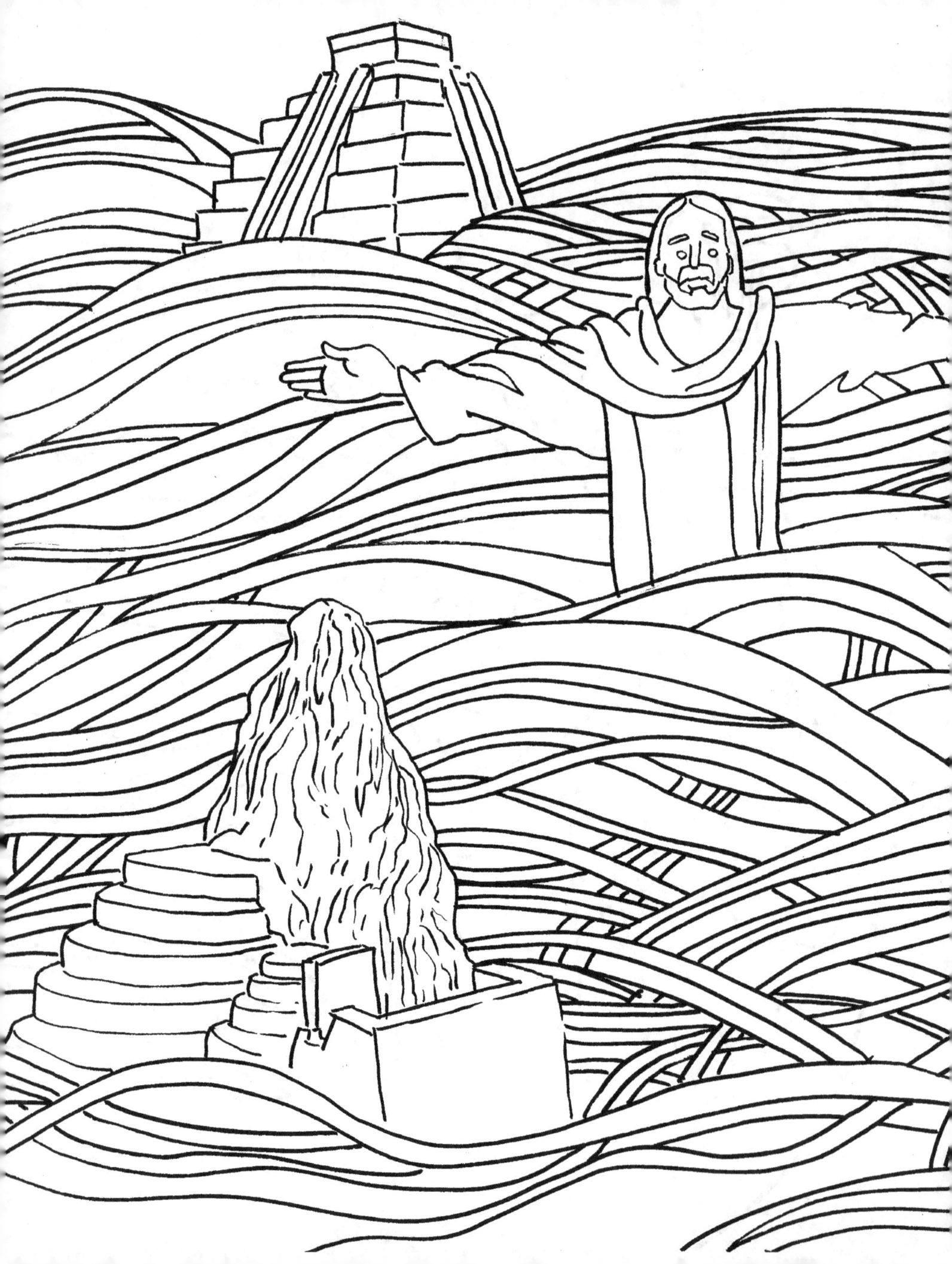

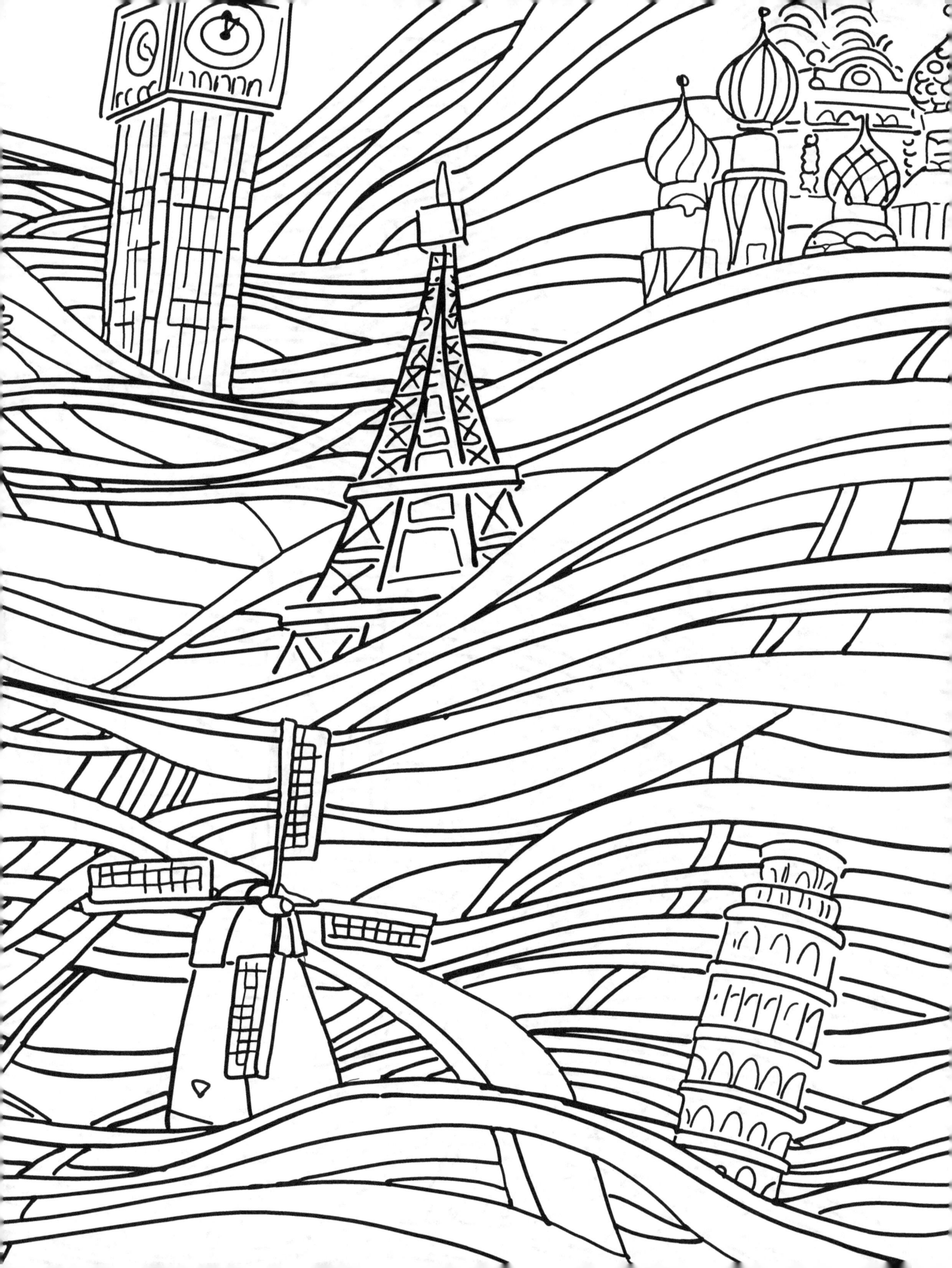

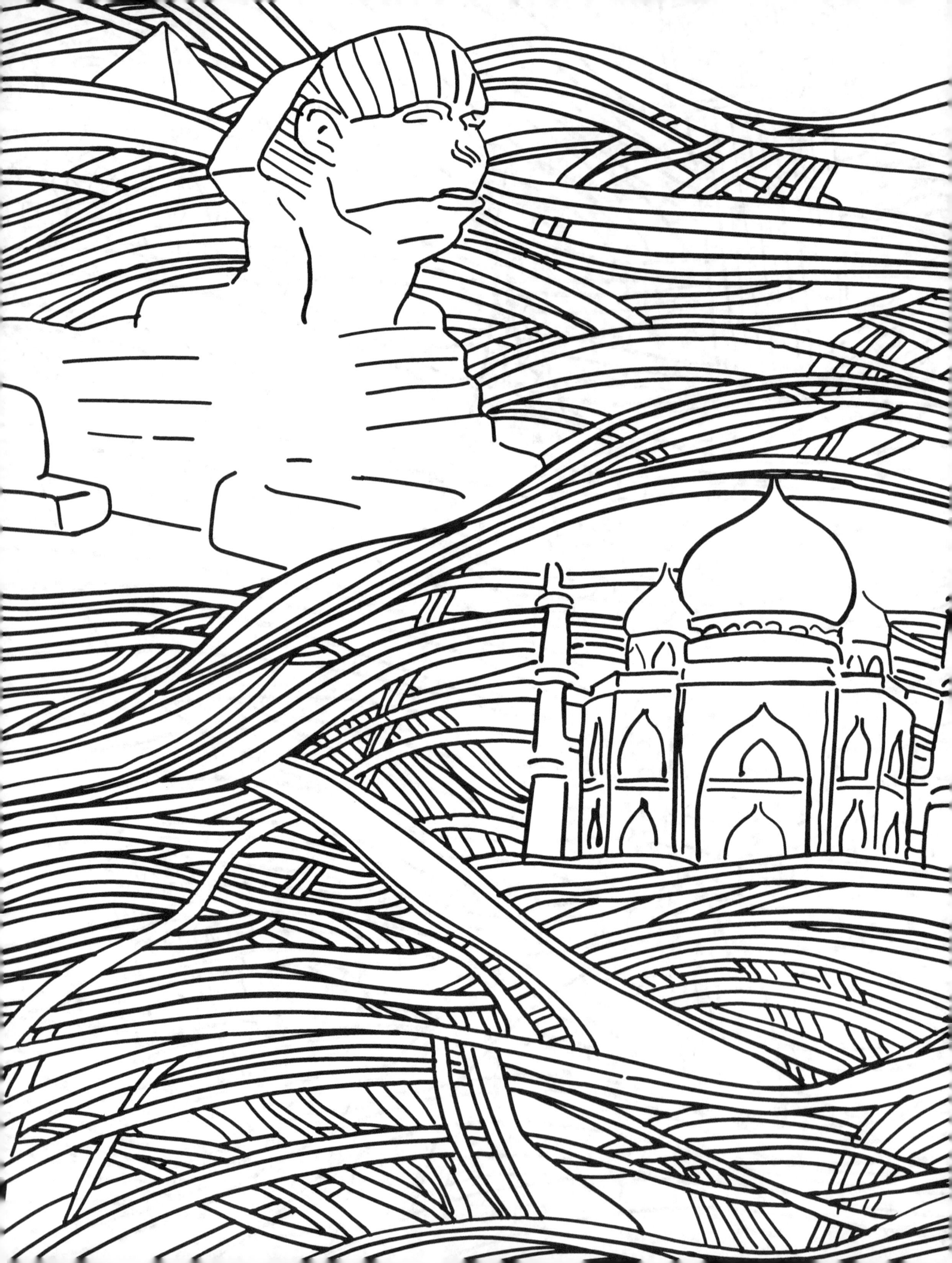

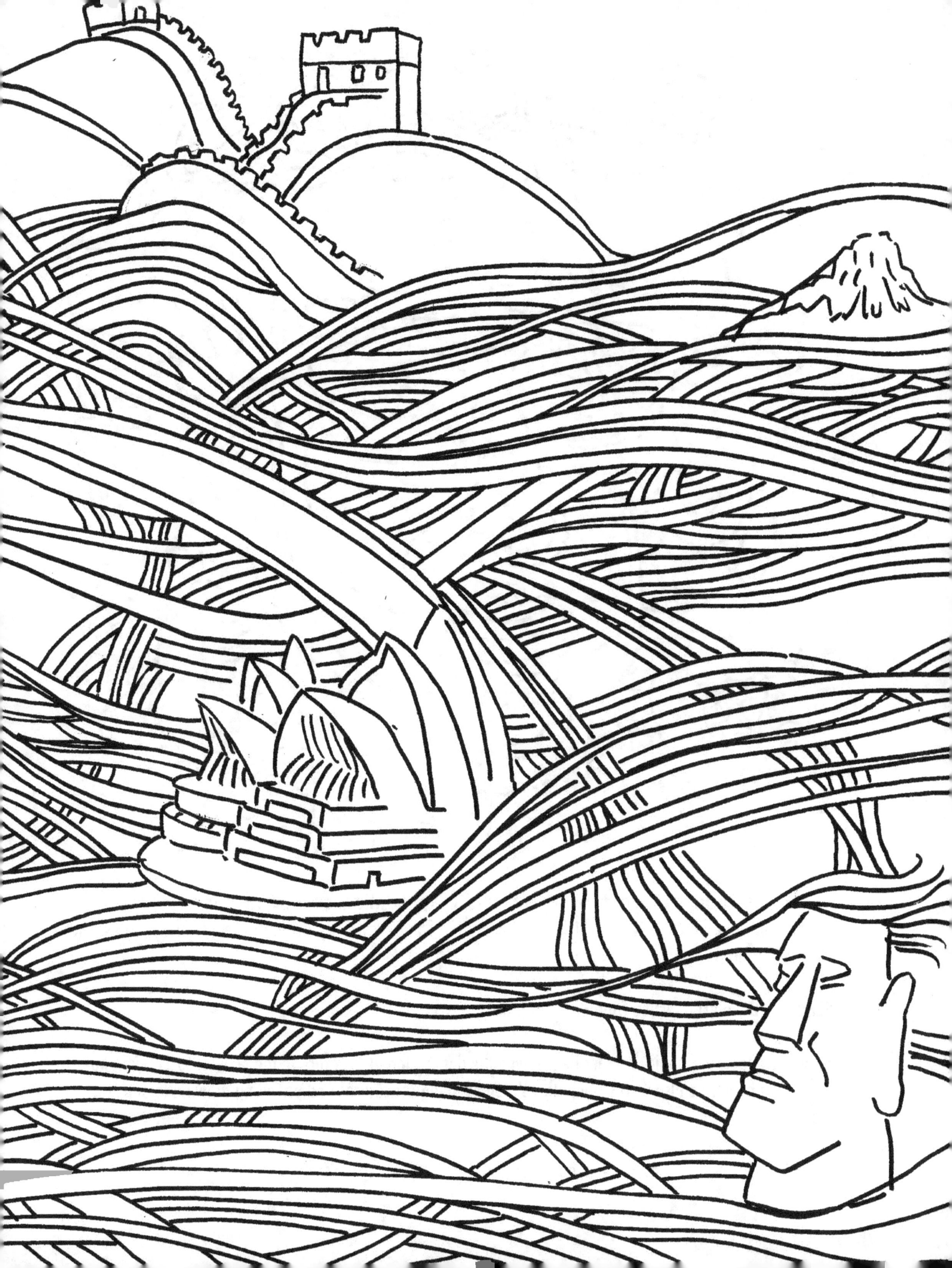

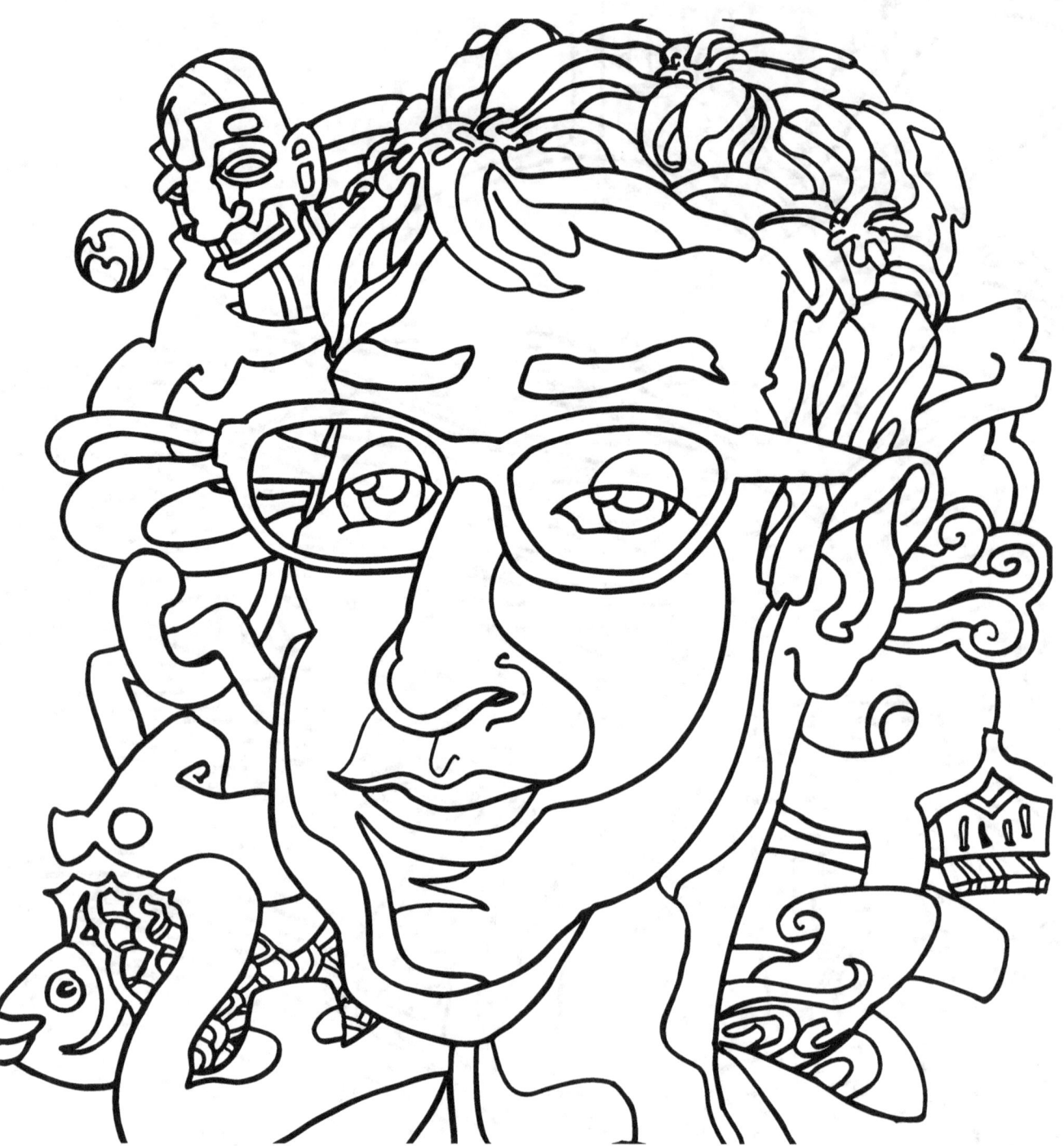

Evan Forsch is an artist living and working in New York City. His wife and two boys inspire, encourage, and prevent him from doing his work, which has appeared in *The New Yorker*, *Reader's Digest*, *Funny Times*, and other publications.

Evan has a BA in art direction from Pratt Institute.

While working as a graphic designer he survived the destruction of his office in the WTC on 9/11. Evan now works from home. He also works from others' homes doing caricatures and providing drawing lessons for artists of all ages.

Follow Evan on Twitter, Instagram, and Facebook @evan4sh

www.ingramcontent.com/pod-product-compliance
Lightning Source LLC
Chambersburg PA
CBHW081118180526
45170CB00008B/2906